THE DIGITAL PHOTOGRAPHER'S GUIDE TO
EXPOSURE

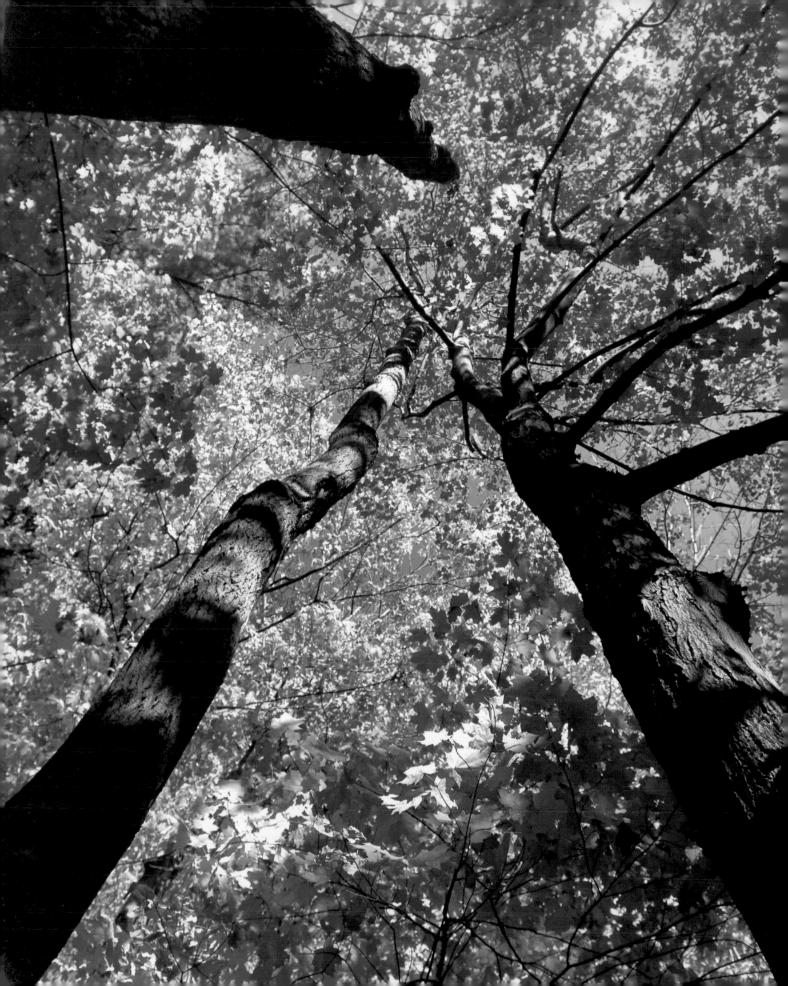

THE DIGITAL PHOTOGRAPHER'S GUIDE TO

EXPOSURE

PETER COPE

D&C
David and Charles

A DAVID & CHARLES BOOK
Copyright © David & Charles Limited 2008

David & Charles is an F+W Publications
Inc. company
4700 East Galbraith Road
Cincinnati, OH 45236

First published in the UK in 2008
First US paperback edition 2008

Text copyright © Peter Cope 2008
Photography copyright © Peter Cope 2008
(except those acknowledged on p144)

A catalogue record for this book is available
from the British Library.

ISBN-13: 978-0-7153-2774-6 hardback
ISBN-10: 0-7153-2774-7
ISBN-13: 978-0-7153-2779-1 paperback
ISBN-10: 0 7153-2779-8

Printed in Singapore by KHL
for David & Charles
Brunel House, Newton Abbot, Devon

Commissioning Editor: Neil Baber
Editorial Manager: Emily Pitcher
Desk Editor: Demelza Hookway
Proofreader: Nicola Hodgson
Project Editor: Ame Verso
Designer: Eleanor Stafford
Indexer: Lisa Footitt
Production Controller: Beverley Richardson

Visit our website at www.davidandcharles.co.uk

David & Charles books are available from all
good bookshops; alternatively you can contact
our Orderline on 0870 9908222 or write to us at
FREEPOST EX2 110, D&C Direct, Newton Abbot,
TQ12 4ZZ (no stamp required UK only);
US customers call 800-289-0963 and
Canadian customers call 800-840-5220.

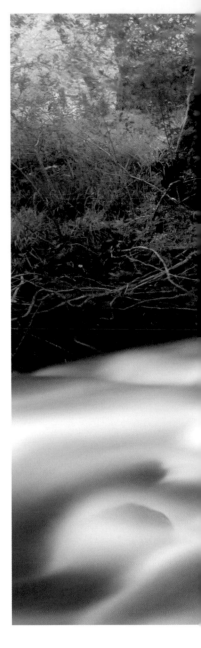

(PREVIOUS PAGE) TREE CANOPY
As autumn advances, vibrant colours fill
nature. Careful exposure ensures that these
are maintained and not lost in a silhouette or
washed out as the camera exposes for the
large dark areas.

RIVER
Exposure mastery doesn't just mean that
you can accurately reproduce scenes as they
appear to you. You can also, as this shot
shows, capture evocative scenes that a simple
shot would not. Here the photographer has
used an extended exposure time coupled
with a small lens aperture to transform this
river scene into something more ethereal.

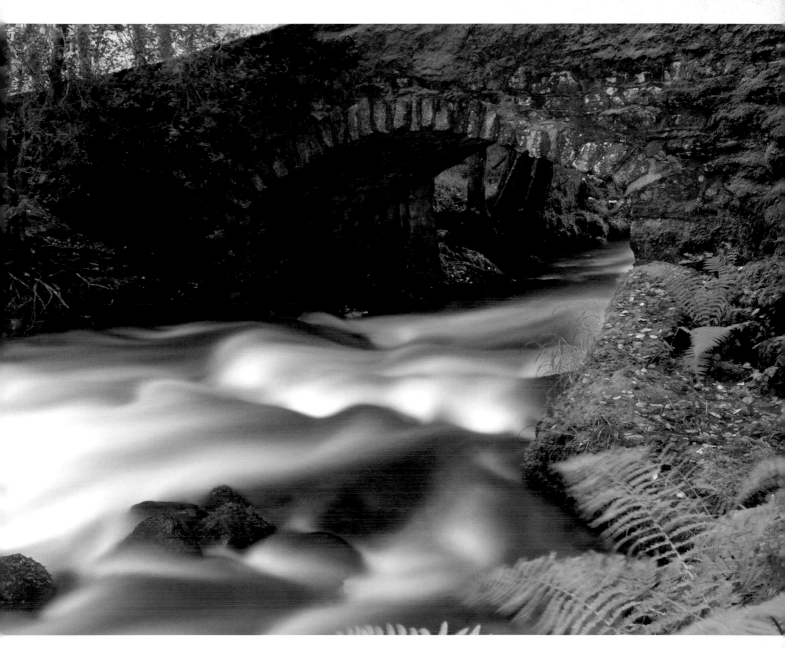

CONTENTS

INTRODUCTION

I'm a great fan of automatic features on cameras. Autofocus, autoexposure: I think they are brilliant. That comment might cause a raised eyebrow with many photographers, who can be a bit 'sniffy' about anything that takes control away from the photographer. My love of such features goes back to my youth when, armed with my first serious camera (that is, one that offered some degree of exposure control), I was continually thwarted in my ambitions to shoot great action shots. So often I would miss the proverbial – and sometimes actual – boat, capturing the moment just a fraction of a second too late. Frantic setting of shutter speed, aperture and finding perfect focus took just that little bit too long.

Of course, you could argue that this is the photographer's equivalent to the fisherman's tale of the one that got away. That perfect shot that would have secured my reputation was there for the taking – I was just that bit late for it. Think about the implications of this. Photographers historically have spent a lot of time – often critical milliseconds – making adjustments that were, for the most part, purely mechanical; ones that did not require overt skill. Today, cameras are quite capable of making these adjustments faster and more accurately than you were ever able to.

The central processor – the 'brain' – in your camera is ruthlessly efficient and absolutely objective in its operation. All requisite settings for perfect exposure – and more besides – can be made at the touch of a button.

While that's fine for simple, objective photographs, often the aim is for something more and that's where this book comes in. Now that virtually all cameras take care of the essential management, your attentions can be devoted to exploiting the power of creative exposure control.

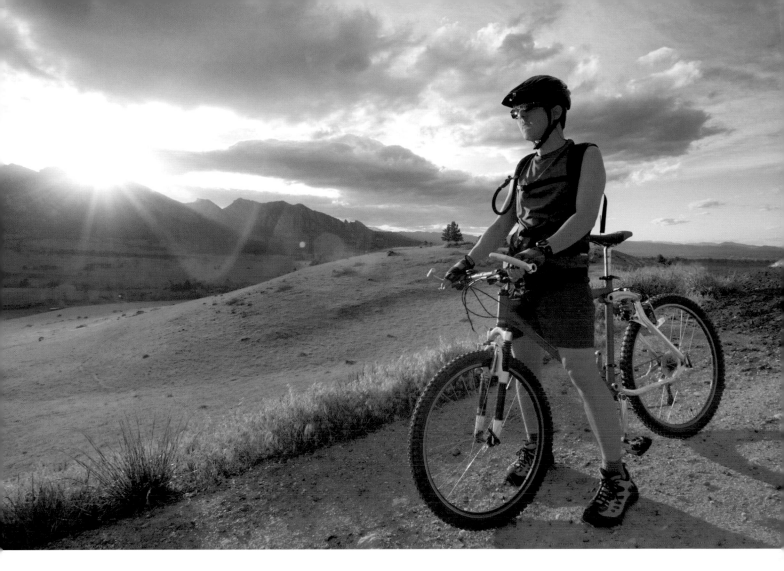

BIKE AND RIDER
Brightly lit evening skies, a wide brightness range and backlighting all conspire to make this a difficult scene to expose correctly.

LONG EXPOSURES
Night scenes take on an ethereal feel when shutters are kept open for extended periods.

THE ART OF EXPOSURE

Creative exposure is not about setting the correct exposure – something the camera can do very well on its own; it's about determining the best exposure, something that is subtly and critically different. So what is the difference between *correct* exposure and the *best* exposure?

Often the clearest way to appreciate best exposure, whether that exposure has been achieved in-camera, by image manipulation on a computer, or (more likely) by a combination of the two, is by example. That's why throughout this book you'll find images taken by photographers who've realized not only the importance of best exposure but also the impact. With just a modest amount of forethought, exposure considerations have transformed a good photo into a great one. These images are outstanding yet attainable, and if you read this book you'll understand how. You'll also discover the tools that can make your picture-making so much easier.

Ask a photographer what the key tool for exposure control is and they are likely to say, 'the exposure meter'. That's true to a point, and this book certainly explores how you can use meters to their best, but undoubtedly a more potent tool is light. It's something that is taken for granted and something that you and your camera merely respond to. This book not only explores the nature and form of light but also teaches you how to exploit it, to make it work with you and for you.

Traditionally, professional and serious enthusiast photographers would enhance their photographs in the darkroom. By modifying the way light falls on the photographic paper, exposure control and modification that was begun at the time of shooting could be accentuated. All photographers now share the benefits of the digital darkroom, which has far more power than its predecessor. You'll discover that digital image manipulation is not a cure-all, but it is a way of making a good thing better. So, let the adventure begin!

CHAPTER 1:
THE SECRET OF GREAT PHOTOGRAPHY

Whether you choose to browse online stores or the traditional bricks-and-mortar variety, you can't fail to be impressed by the range of cameras on offer. Spurred on by advances in digital technology, even the most basic and pedestrian of models is now capable of delivering impressive results.

Most cameras – including professional models – now boast fully automatic operation, whether as a matter of course or as a selectable mode, that will take control of all the camera's key features, from focusing through exposure setting and even flash. There is no doubt that this is a great boon to all photographers; even when time is at a premium there is no longer an excuse for below-par shots. But isn't there something missing? When you set out to take a photograph you have a certain vision in mind. You may, for example, want to take a romantic portrait. Or you might want to capture a powerful landscape. This is where the 'auto everything' approach comes unstuck. Switching to fully automatic denies the vital link between your vision and the resulting image.

When you aim to shoot that impressive portrait the camera has no idea that, for example, you wanted the emphasis on the subject and not the background. It doesn't – indeed it can't – know that you also wanted the exposure based on a particular element in that scene. The result? A good photograph, but not a great one. That's why exposure mastery is so important. Crucial to this is having a fundamental grasp of what is meant by exposure. This chapter examines the cornerstones of exposure so that you gain an essential understanding of it.

STARFISH
Bright daylight allows for a short exposure – sufficient to freeze the motion of the incoming wave – and small aperture – sufficient to capture the greater part of the scene in sharp focus. The scene was metered from the sand, which allows the modest amount of surf at the head of the wave to be rendered bright white and permits the capture of the maximum brightness range in the scene.

WHAT DOES EXPOSURE MEAN?

Exposure is one of the most fundamental concepts in photography – and one of the most abused terms. It can be wrongly used as a synonym for 'shot': 'that's a great exposure!' Or, similarly, you might hear, 'how many exposures have you got left on that card?' Everyone knows what is meant by these comments – indeed, you might use them yourself – but what does the term 'exposure' really mean?

In a dictionary of photography you'll find exposure defined as: 'the total amount of light allowed to fall on a camera's sensor in order to take a good shot.' That raises the question 'what is a good shot?' Rather than answer that I would go for a slightly different definition: 'the total amount of light allowed to fall on a camera's sensor as determined by a metering system and the skill and judgment of the photographer required to produce a great photograph.' After all, you want to take photographs that are excellent rather than merely 'good'. A good exposure, then, should be viewed as a combination of technical prowess and more subjective judgment.

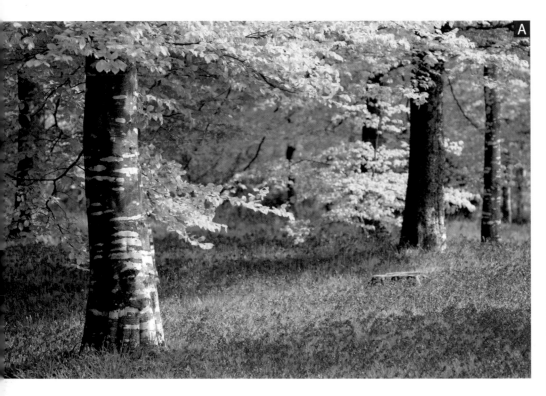
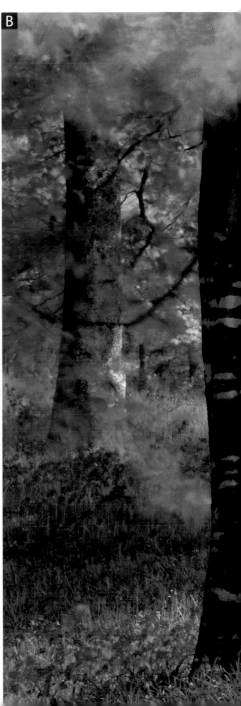

VARYING SHUTTER SPEED
Decreasing the shutter speed (allowing the shutter to be open for a longer period) allows the photographer to record motion in a shot. In the shot taken with a fast shutter speed (A), everything is recorded in sharp focus. In the shot taken with a slower shutter speed (B), the effect of wind moving the tree's branches is made more apparent, while the remainder of the shot, which was static, remains sharp.

BACK TO BASICS

To gain a fundamental understanding of exposure it's a good idea to revisit the essentials. These encompass the crucial concepts that those new to photography may have successfully avoided and others neglected.

Each photograph you take comprises a combination of shutter speed and lens aperture that delivers the correct amount of light to the image sensor. The lens aperture, sometimes called the iris, plays a similar role to that in your eye. It opens and closes to regulate the amount of light that enters. When the aperture is wide more light can enter and when small, less.

The shutter is a physical barrier that prevents light getting through from the lens to the sensor – except when you press the shutter release. Then, the shutter opens for a pre-determined length of time before closing again. You'll probably begin to realize now that there is a relationship between aperture and shutter speed. If you want a given amount of light to reach the sensor you could do so by setting a certain shutter speed and aperture. You could get the same result by opening the shutter for twice as long but closing down the aperture so only half as much light can enter.

It is worth noting here (and we will expand upon this theme later) that this inter-relationship between shutter speed and aperture is one that has its basis in film photography. In our digital world there is a third parameter – sensitivity – that can be used to control exposure. The sensitivity of the film was fixed, either on the basis of the nominal speed, or on a modified speed produced by adjusting the processing characteristics.

In a digital camera we can, within certain limits, adjust the sensitivity of the digital sensor. This allows the photographer extra latitude in exposure where it might be needed, although it is probably fair to say that it is the aperture and shutter speed that will be used most often.

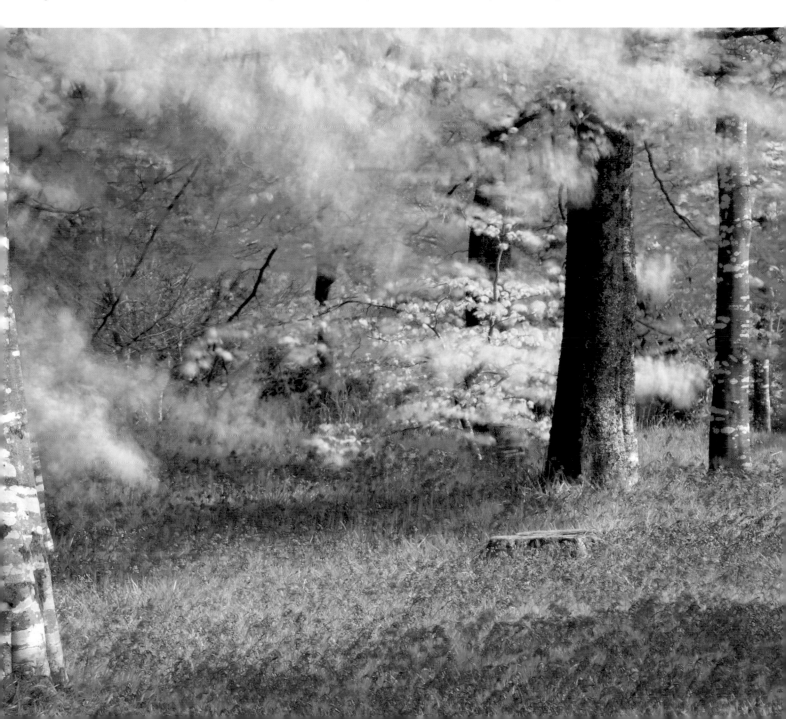

EXPOSURE VALUE

There are, then, a whole series of combinations that give the same exposure. That's why photographers often use the term Exposure Value (EV). An EV describes the set of combinations (of aperture and shutter speed) corresponding to an identical exposure.

While all camera-setting combinations that deliver the same EV give the same exposure, they will not always give the same photograph. This is because varying the aperture will alter the depth of field (see page 16) and altering the shutter speed will alter the amount of blur if there is motion within the scene (see page 18).

It's also worth noting that you can't normally set an EV directly on a camera; you can only set one of the corresponding aperture/shutter speed combinations. Some cameras will, however, let you set one combination and then alter this to another with an equal EV. Also, some exposure meters (see page 36) will display the EV along with aperture/shutter speed combinations. In this book, although I will talk about EV, because the look of a photograph is so often determined by the depth of field – or the area of sharpness – I will tend to describe exposure in terms of shutter speed and aperture. Only where there is no benefit to be gained through the use of a specific aperture or shutter speed combination do I refer solely to EV.

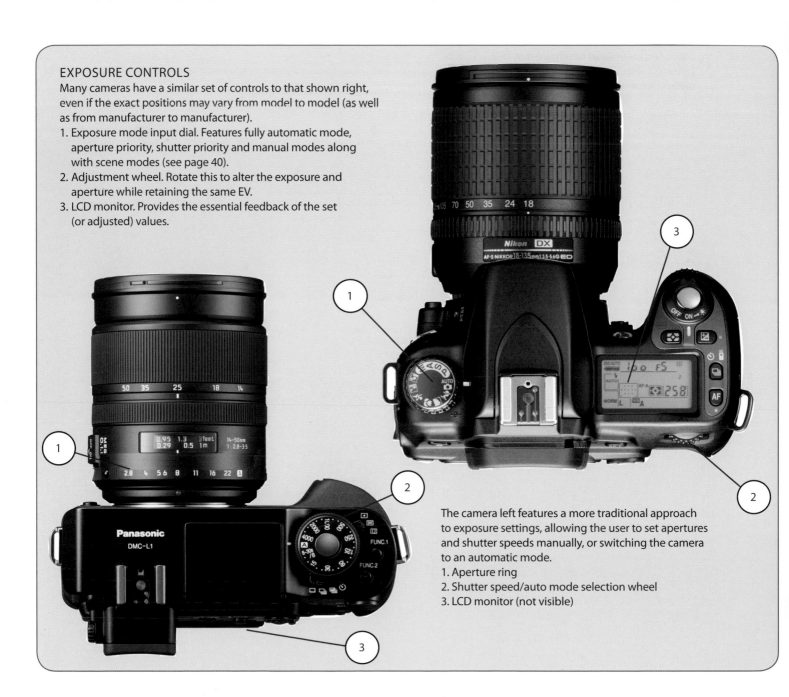

EXPOSURE CONTROLS
Many cameras have a similar set of controls to that shown right, even if the exact positions may vary from model to model (as well as from manufacturer to manufacturer).
1. Exposure mode input dial. Features fully automatic mode, aperture priority, shutter priority and manual modes along with scene modes (see page 40).
2. Adjustment wheel. Rotate this to alter the exposure and aperture while retaining the same EV.
3. LCD monitor. Provides the essential feedback of the set (or adjusted) values.

The camera left features a more traditional approach to exposure settings, allowing the user to set apertures and shutter speeds manually, or switching the camera to an automatic mode.
1. Aperture ring
2. Shutter speed/auto mode selection wheel
3. LCD monitor (not visible)

RIGHT CAN BE WRONG

Today's cameras are blessed with exposure systems that have a competence that could only be imagined a few years ago. In some situations, however, the right exposure – that defined by metering systems – doesn't describe an exposure that will give the best image. So on occasions the reading that your meter determines, though useful as a guide, should not determine the actual exposure.

Sunset shots are a good case in point. Consider the example shown here. The correct exposure (that determined by the camera's meter, or an external handheld meter) is represented by the bright shot here. It's technically a perfect exposure but it does not represent an accurate rendition as you might have remembered such a scene. Underexposing by 1 EV (by reducing the aperture by 1 stop, or reducing the exposure time by half) gives a much more colourful result. Doing this by 2 stops produces an even more saturated and evocative result.

Which of these shots is right? There's really no right or wrong. The best shot is that which you consider to be the best.

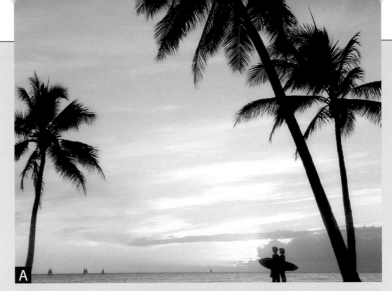

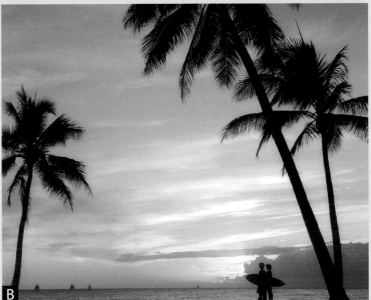

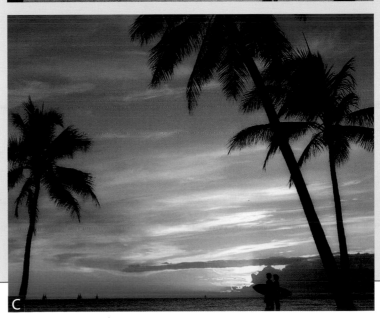

SUNSETS
Technically the first image in this set (A) is the correct exposure, but this lacks the colour and delivers a less emotive image than those achieved by underexposing by 1 stop (B) or 2 stops (C).

LETTING THE LIGHT IN

So, to regulate the amount of light entering a camera you can vary the aperture or the shutter speed. Or the aperture and the shutter speed. You need to do this in a considered way, and a way that correlates directly to the amount of incoming light.

HOW TO CONTROL THE APERTURE

The aperture – that opening in the lens – is fundamental in regulating the amount of light that can enter the camera. It has been recognized as this for so long that early on in photography's history photographers understood that there needed to be an ultimate way of defining aperture; a way that was consistent and reliable no matter what lens was used. The method they devised – which has stood the test of time and is still used today – is known as the f (for focal) ratio (whose increments are called f-stops or f-numbers) and, because it is a ratio, is entirely independent of the lens – or auxiliary optics – in use.

What is the f ratio? Simply put, it is the ratio between the focal length of the lens in use and the diameter of the circular aperture. It might be clear from this that the larger the f-number the wider the aperture and, of course, vice versa.

F-numbers, or stops, follow a geometric sequence where each successively larger f-number represents an aperture half the size of the previous one. Consequently, when we talk about reducing the exposure by 1 stop

Aperture settings

f-stops	2	2.8	4	5.6	8	11	16	22	32
half f-stops		2.3	3.5	4.5	6.7	9.5	13	19	27

Technical tip

STOPS AND FULL STOPS

It's useful to think of a stop (or full stop, they mean the same) as a doubling or halving of the quantity of light received by your camera's sensor. That quantity can be varied by altering the aperture or the shutter speed. Photographers often talk about 'stopping down' – reducing the exposure – or 'opening up a stop' when increasing the exposure. These changes may be effected by aperture or shutter speed adjustments.

WHY TWO APERTURES?

Lenses are described by their focal length and maximum aperture. Some zoom lenses (on compacts and digital SLRs), however, are quoted as having two maximum apertures. A lens may be described as 55–200mm f/4–f/5.6. Why is this? The construction of some zoom lenses is such that the lens has a maximum aperture of f/4 at the wide end of the zoom range (55mm) but only f/5.6 at the telephoto end. In practice, the lens is a stop slower at the longer focal length. Be aware of this change in aperture at the longer focal length as this could compromise handheld shots. Not only will the magnified images demand a shorter exposure but the lower aperture will also force a longer one. Where only one aperture is quoted you can assume this will be constant across the zoom range.

ONE STOP

Examine the first image (A), and then notice that just a 1-stop increase in exposure can make quite a difference (B). Also an increase of 1 EV, twice as much light is now reaching the sensor. Note how highlights have extended and are now featureless. Shadow areas are also compromised.

we mean cutting the exposure (assuming the shutter speed remains the same) in half; by 2 stops, reducing it to one-quarter. The difference between two apertures (again presuming the shutter speed remains unaltered) is also 1 EV.

If you exclude some specialized optics, all lenses are calibrated in (and usually allow setting to) the regular series of f-numbers shown in the table left. You can see that the numbering follows a regular sequence, though the half f-stop numbers I've noted here tend to be used less commonly. You are more likely to see these figures marked on zoom lenses.

ALL ABOUT SHUTTER SPEEDS

As the second parameter in determining exposure, you could expect shutter speeds to offer a similar sequence – with a series of settings each half the preceding or following in duration (or light gathering) – and that's exactly what you do find. The conventional sequence is shown in the table above right and, again, a difference of 1 full stop (this time assuming the aperture remains constant) equates to a change of 1 EV.

Shutter speed settings (in seconds and fractions of a second)													
stops	1	1/2	1/4	1/8	1/15	1/30	1/60	1/125	1/250	1/500	1/1000	1/2000	1/4000
half-stops	0.7	1/3	1/6	1/10	1/22	1/45	1/90	1/180	1/350	1/750	1/1500	1/3000	

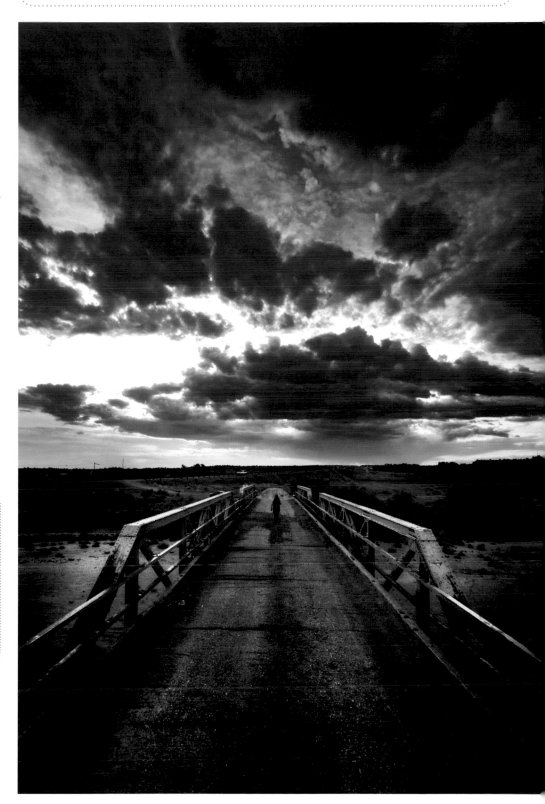

Technical tip

HALF OR ONE-THIRD STOPS?
Cameras today can make their adjustment of shutter speed or aperture to precisely the value that the light levels determine, but how precisely can you set them manually? On many cameras – where adjustment is possible – you can do so to the nearest half-stop. Others – especially those designed for the enthusiast or pro – provide the more subtle adjustment increments of one-third of a stop.

YELLOW BRIDGE
A strong composition of the converging lines of this roadway combine with deliberate underexposure to enhance the dark brooding sky. A neutral density filter has been used over the sky to darken the clouds further without making the yellows and greens in the landscape muddy.

EXPOSURE MODES

You will have realized now that there is more to getting an exposure right than simply setting a shutter speed and an aperture. With a range of settings corresponding to the nominally 'correct' EV value you need to consider how to set a combination that is best suited to the photography you have in mind. This can be achieved through judicious use of exposure modes.

Though some cameras may boast a great number of modes, many of these will be quite specialized. You will find that there are three key modes that you will use for the majority – if not all – of your shots. Each of these has a key place in your photography and you will need to spend a little time becoming familiar with each.

Aperture priority – you determine the aperture and the camera takes care of the shutter speed.
Shutter priority – you set the shutter speed and the camera sets the aperture accordingly.
Manual – you have full control of both aperture and shutter speed.

APERTURE PRIORITY

Aperture priority is often called semi-automatic or semi-auto, for the obvious reason that the aperture setting is made manually and the shutter speed is chosen automatically. It is denoted by AE or (confusingly, as it could be mistaken for Auto) simply A on some cameras.

To begin to see the benefits of aperture priority – it's the mode most photographers use for most of their shots – you need to consider what types of photography it benefits.

Aperture priority is especially useful in landscape and portrait photography. In each of these cases it is the amount of the scene that is in sharp focus that is crucial. For a landscape you would like as much of that scene as possible to

Technical tip

MODIFYING APERTURE

In very bright conditions you may not be able to set a very wide aperture – the shutter speed range won't accommodate it. In these situations you can use a neutral density filter (see page 29) – a neutral grey filter that reduces the amount of light entering the lens, allowing the setting of wider apertures.

be in sharp focus. That may mean everything from a foreground object through to the distant hills. Conversely, in portraiture you would want the subject in sharp focus but the potentially distracting background to be out of focus.

Aperture priority provides this creative power thanks to the control that it offers over depth of field. Although many photographers use aperture control merely as a way of altering the amount of light entering the camera, understanding the consequences of these adjustments – varying the depth of field – can be empowering to your photography.

DEPTH OF FIELD

The term 'depth of field' describes the amount of a scene that is in focus. When you focus on a subject, the zone of sharp focus will extend a little in front of and a little behind that subject. How much is in focus is determined by the aperture. A wide aperture results in a very shallow area being in focus – a shallow depth of field. You might find, for example, if you shoot a portrait at a very wide aperture, that the subject's eyes are in sharp focus but the nose is blurred. If this was not your intention, you'd need to reduce the aperture to extend the zone of focus.

For a landscape shot that you want in sharp focus throughout, you need to select the smallest possible aperture. At small apertures the depth of field is extensive.

APERTURE RING
The aperture ring found on many cameras provides an easy way to adjust the aperture. Changes made are displayed in the viewfinder, saving the need to check the setting directly.

Pro tip

ESTIMATING AND PREVIEWING DEPTH OF FIELD

Camera lenses used to be marked with depth-of-field scales that correlated with the distance scale on the focusing ring. You could see at a glance the depth of field and adjust the position of focus to achieve the best results. New lens designs have generally dropped this. With a digital SLR you don't automatically get an impression of the depth of field when you look through the viewfinder. You can, however, see such by activating the depth-of-field preview button. Press this and the iris closes down to reveal the depth of field. This may darken the viewfinder, making composition more difficult, but it is useful for checking the effect of your selected aperture. Once happy, release the preview button and the viewfinder will lighten again, allowing you to compose your shot unhindered.

ZONE OF FOCUS

When a camera focuses on a subject, an area in front of and behind the subject will also be in focus. Here, the area between the two lines is in focus. Subjects increasingly further away from this area of focus (both in front and behind) will appear progressively more blurred. If you reduce the aperture the area in focus will widen, allowing a greater area in front of, and behind, the subject to be rendered sharp. Increase (open) the aperture and this area will become shallower.

Technical tip

MAXIMIZING DEPTH OF FIELD

To get the maximum depth of field in a landscape, say, select the smallest practical aperture and focus on a point one-third of the way into the scene. With a small aperture everything in front of and behind this point should be rendered pin-sharp.

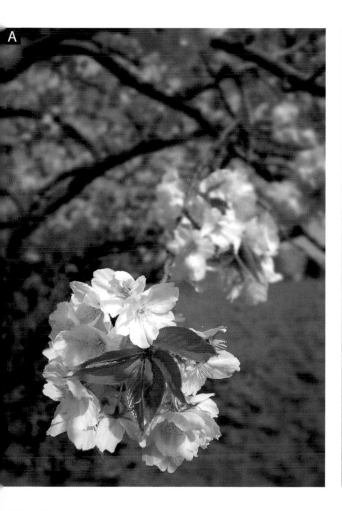

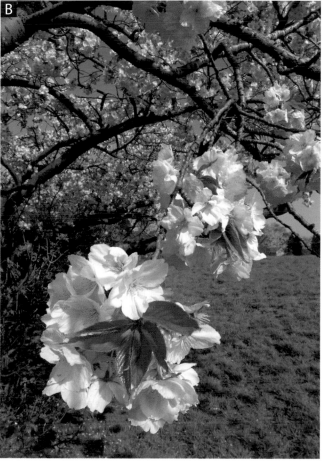

DEPTH OF FIELD

Though both these shots have the same EV, the aperture for the first shot was wide (A), rendering only the flower head in sharp focus – an example of narrow depth of field. For the second shot (B), the aperture was reduced, widening the depth of field. Note that even distant parts of the scene are rendered more sharply.

SHUTTER PRIORITY

What landscape and portrait photography have in common is that photographs can be shot in a fairly relaxed manner. Photographers adept in either genre will advise that to get the best results requires time and patience, both of which can be exercised to the full when shooting these subjects. For some photography, however, time is very much of the essence and a moment's hesitation could mean the difference between a good shot and, perhaps, no shot at all. These are the shots where there is motion of some sort in the frame. It could be fast motion, such as that which you might find when shooting action sports, or something more relaxed, such as flowing water or even the effect of wind.

For these situations, an alternate, complementary mode – shutter priority – comes into its own. Having control of the shutter speed means that you can choose a fast (or ultra-fast) shutter speed to freeze the action on a sports field or racetrack. Or you can shoot images where long exposures – running to a second or more – can be set to enhance motion and even create surreal effects through the result of motion blurring.

SHUTTER SPEED DIAL
Some cameras offering a shutter priority mode feature a dial that can be used to select the appropriate speed. Other cameras may have menu settings or thumbwheels to make similar adjustments.

To gain an appreciation of the effect of shutter speeds on your shots it's useful to fire off some test shots of moving water. You've probably seen those dreamy romantic photographs of a river where the water has taken on the appearance of a misty ribbon of silk. Such images are not realistic but are very compelling. They are the result of shooting with exposure times often of many seconds. Reduce the shot duration to, say, 1/60sec (one-sixtieth of a second) and the river takes on a more conventional appearance. At the other end

FAST SHUTTER SPEED
A high – or very high – shutter speed freezes fast-moving subjects. You need to ensure that you use a speed high enough to freeze motion entirely. Anything less can show a degree of blurring.

of the shutter speed range – when you get to brief speeds of 1/500sec or shorter – flowing water can be frozen and individual droplets captured. Of course, if you're aiming for photorealism, the ideal shot is somewhere between these two extremes.

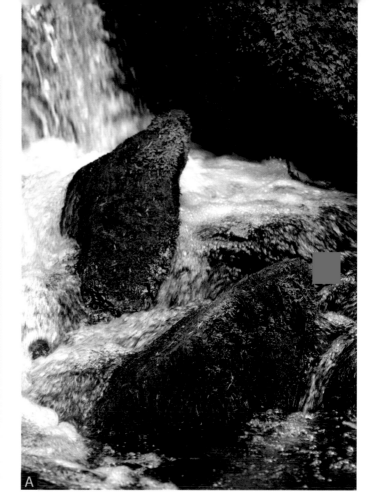

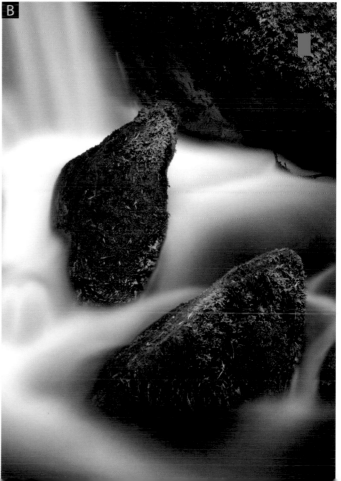

PANNING TO FREEZE MOTION

Sometimes, if you're shooting fast-moving objects when the light isn't at its best you won't be able to set a fast enough shutter speed to freeze the action. Instead, choose the fastest possible speed and pan the camera to follow the subject. Then gently release the shutter. Result? Your subject will be in sharp focus and the background will be blurred. Many photographers use this technique to emphasize or even exaggerate the amount of motion. It takes practice to get it right, but is a technique well worth mastering.

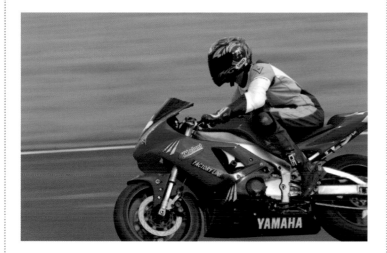

PANNING
Tracking a moving subject can help freeze motion but render the background blurred. This can be useful for emphasizing motion and speed.

SHIFTING YOUR EXPOSURE

To take the image you consider to be optimum may require a certain shutter speed (or a range of shutter speeds) to control the amount of motion blur, and certain apertures to determine the depth of field. Many cameras – and virtually all digital SLRs – let you shift the chosen exposure setting, usually using a thumb or fingerwheel on the camera grip. The idea is that you compose your image, set the appropriate exposure (using aperture priority, shutter priority or even fully automatic mode). Then you rotate the wheel to get different shutter speed/aperture combinations.

Here's an example. If the exposure is set to 1/500sec at f/8, rotating the shift control one way will alter the settings to 1/1000sec at f/5.6 and the other to 1/250sec at f/11. You can continue to shift the settings in both directions as far as the camera's settings will allow. This can be a quick way to get your chosen setting, particularly if the camera is set to fully automatic.

FLOWING WATER
Shoot flowing water using a high shutter speed and you can virtually freeze every drop (A), but extend the shutter speed and you'll get a soft, dream-like effect (B).

MANUAL METERING

Today when the effectiveness of auto and semi-auto metering modes is undoubted, there seems little reason to resort to the antithesis – fully manual metering. After all, every mode uses the same metering system and the same rule base is applied in-camera to interpret the readings. Surely, having one of your essential settings – aperture or shutter speed – taken care of automatically is sufficient?

In fact, several situations might demand a switch to manual: extreme lighting, for example. If you are shooting in very low light levels you might want to make settings that no automated mode would – or could – assist with. At low light levels the built-in exposure meter might still provide accurate results but at these levels the difference between a technically well-exposed shot and a good image are more marked.

Then there may be times when you might use a handheld meter. Different metering systems are examined in Chapter 3 (see page 36), but a handheld meter can sometimes provide readings impossible to match with an in-camera meter. A good case is when you need to take

a reading from a very small area of the image. Though your camera may be able to meter from a small selected area (called spot metering) handheld meters can often deliver even more precise results. If you do use a manual meter then you'll need to transfer the readings from the meter to the camera, in which case you'll need to switch to manual.

Drawbacks? Speed. Setting both shutter speed and aperture, and making any corrections to either of these, is not as fast as a semi-auto mode and certainly not as auto mode. But in difficult conditions configuration speed is rarely an important factor.

PUTTING IT ALL TOGETHER

So, shutter priority gives control over the motion in images, and aperture priority controls the depth of field. Motion blur versus distance blurring. Manual control gives you free range to configure the camera as you wish.

As you become more familiar with exposures in any of these modes, you'll begin to realize that for the ultimate shot you need to consider the consequences of setting a particular shutter

speed and aperture. Your camera, skilled though it is in so many areas, knows nothing of depth of field and nothing of subject motion.

Thomas Edison once – and very famously – said that genius was one per cent inspiration and ninety-nine per cent perspiration. I am sure that he never precisely quantified that figure, nor did he have photography in mind when talking about genius, but there are some parallels.

As many photographers can attest in their quest to photographic perfection, perspiration has been a major factor. But inspiration has a place too. When combined with a total command of exposure the results can be spectacular. Let's take a look at just a few images that show what can be achieved with total command of exposure control.

EVENING FLIGHT
The subject here is the aircraft but exposing for this would result in a featureless sky. However, by manually exposing for the brightly lit part of the sky a more interesting and evocative shot results.

Technical tip

THE QUICK FIX FOR EXPOSURE COMPENSATION

As we have seen, photographers change the exposure by 'opening up a stop' or 'stopping down'. This is a quick way of compensating for objects that need to be recorded brighter or darker than the meter's suggested exposure. Cameras of all types feature an exposure compensation control precisely for this purpose. With it you can dial in compensation of (typically) up to 3 stops above and below the metered setting in one-third stop increments. It does need a little skill to determine what level of compensation is needed, but with digital cameras you can at least get a good impression of the resulting correction on the LCD monitor.

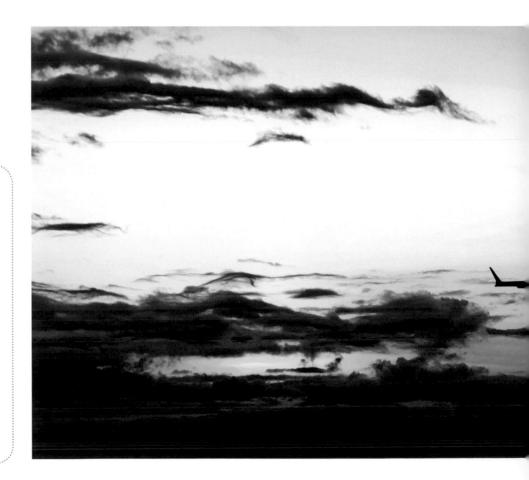

EXTREME LIGHTING
When the lighting conditions are extreme – such as here, with bright, direct lighting and strong silhouettes – even the most competent of automatic exposure systems can be baffled or offer misleading settings. In these cases resort to manual, refining your settings by reference to the camera's LCD monitor.

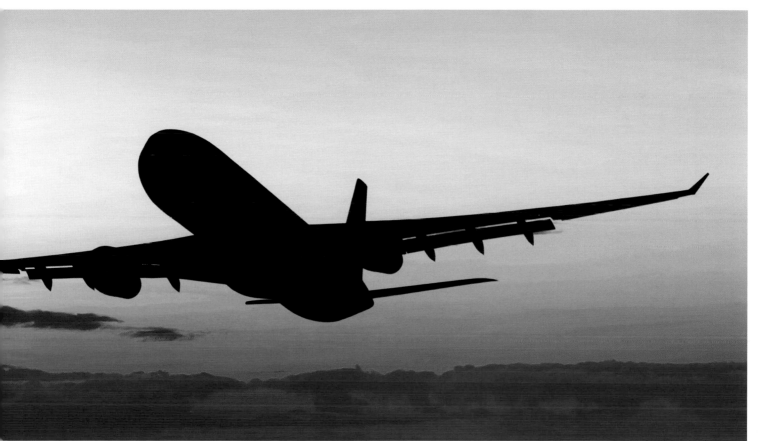

CHAPTER 2:
THE ART OF
EXPOSURE CONTROL

Many photographers today – including a number who consider themselves enthusiasts and semi-professionals – are apt to regard a command of exposure control with less importance than they once did. Their rationale is sound: exposure systems in cameras today are first rate and, in optimal conditions, are often better at judging the correct exposure than they are.

In doing so, however, these photographers are making a fundamental error: what is correct in technical terms is not always the best exposure for a particular scene. How significant is the difference? It can be great, and it is pivotal. Place your trust in the exposure system of your camera and you can deliver images that are consistently good. Spend a little more time and be circumspect about the exposure and you will produce excellent photographs.

There is no doubt that exposure competence is both a technical and an artistic skill. Artistic? Yes, because in setting the ideal (rather than the correct) exposure settings for your photographs you need to have something of a vision about how that image should look. One of the best ways to see the difference a good command of exposure control can make is to look at some examples – some exemplars – of good practice. This chapter looks at how a good eye and command of exposure can contribute to some powerful images.

PORTRAIT WITH SIDELIGHTING
This studio shot by Cathy Waite features a subject shot under lighting conditions that many photographers would consider too problematic. A direct flash illuminates the subject's face, a diffused light picks out the subject's front, and a third light – with a red filter – the background. Although the photographer has control over the lighting environment, the skill here is in ensuring that the highlights on the subject's face are not lost nor the shadow areas reduced to featureless black.

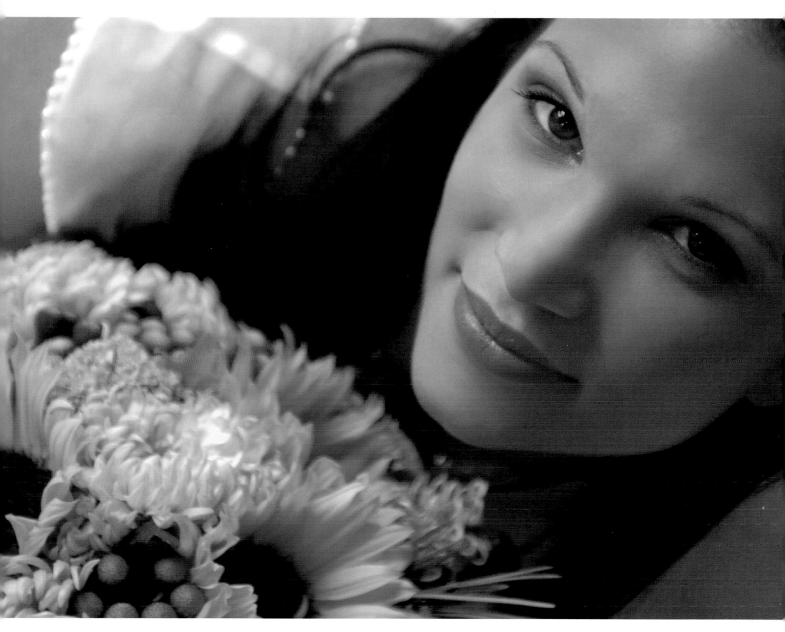

ROMANTIC PORTRAIT
Julie Oswin's portrait uses less extreme lighting than the portrait opposite. She has managed to capture the subtle detail of the skin tones in the subject. Julie needed to ensure that in getting the exposure right for the skin tones the subject's dark brown hair did not become shadowed and featureless. There is a risk that had the exposure been 2/3 of an EV less the hair would lose definition and the left shoulder be rendered rather murky.

BACKLIT PORTRAIT
The use of a strong backlight behind the subject, along with a conventional burst of flashlight from above the photographer's right shoulder, has created a powerful and more compelling image than straight frontal lighting could ever achieve. Mastering the nuances of exposure control will allow you to achieve similar results.

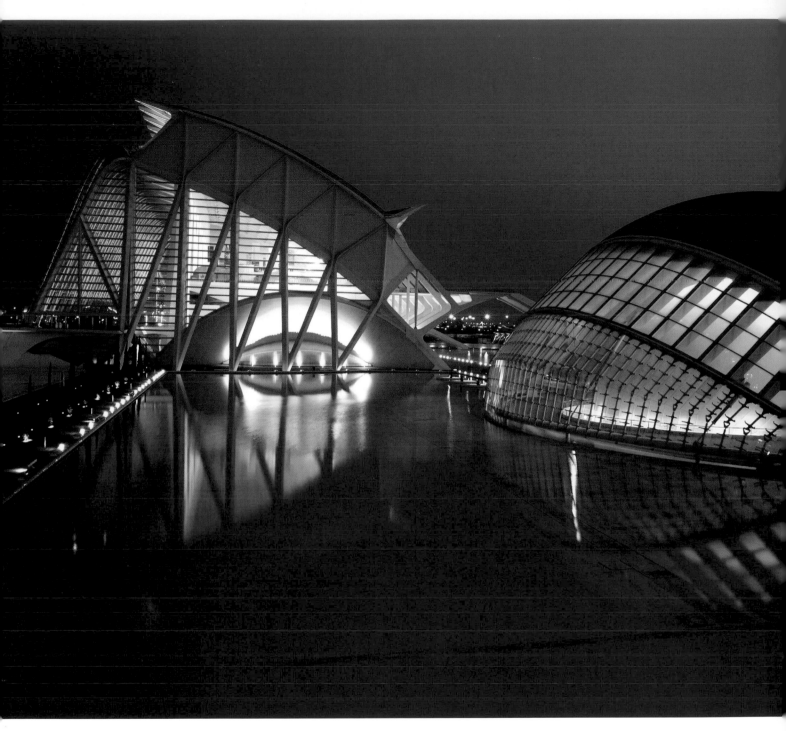

CITY OF ARTS AND SCIENCES AT DUSK, VALENCIA
Dusk is a prized time to shoot urban landscapes, as you can balance the rapidly
diminishing daylight with the artificial lighting. Timing, as well as critical exposure,
is important. You need to balance the disparate lighting sources before one becomes
so dominant that it prejudices an exposure within the range of the camera's sensor.
In Tom Mackie's striking shot of this Spanish landmark, the exposure has been carefully
managed to retain detail in the foreground water and the brighter-lit building interiors.

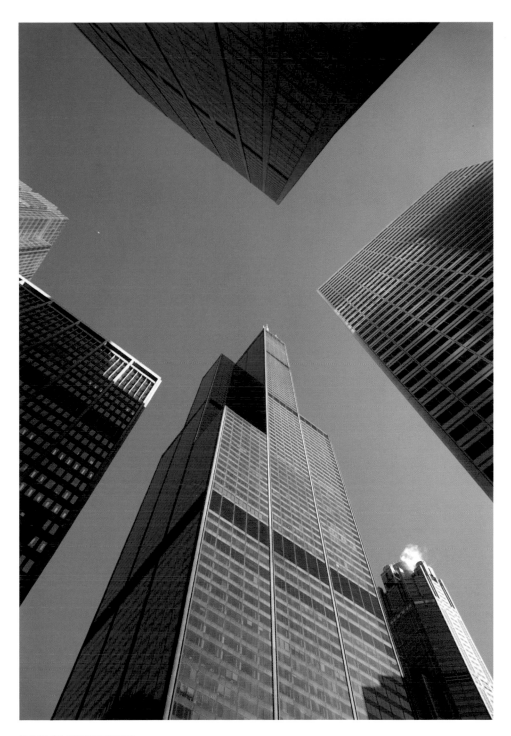

CHICAGO SKYSCRAPERS
In daylight the lighting conditions can be just as problematic. The brightness range between surfaces directly lit by the sun and those in deep shadow can be extreme. Specialist digital techniques can help us overcome this, but the range can also be modified in-camera by, for example, the use of polarizing filters, which cut down the component due to glare.

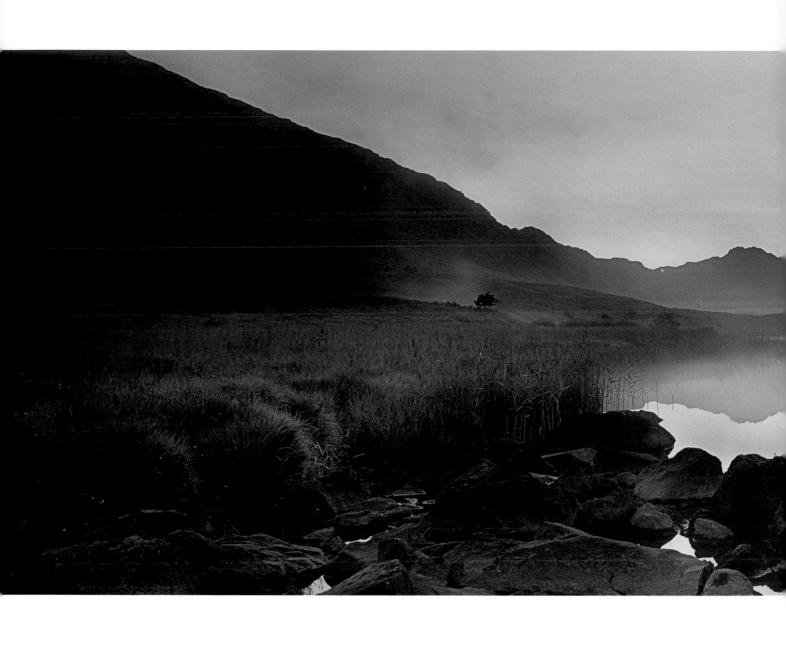

LAKELAND DAWN
Dawn too, is a great time for photographs with fleeting colour and even more transient atmospheric phenomena, as in the mists here. A shot exposed according to the most sophisticated of metering systems would not capture the subtlety of colour and form that Steve Walton has here. Often when there is such an extreme brightness range the camera cannot accommodate it and you may need to employ a neutral density filter to even out the range.

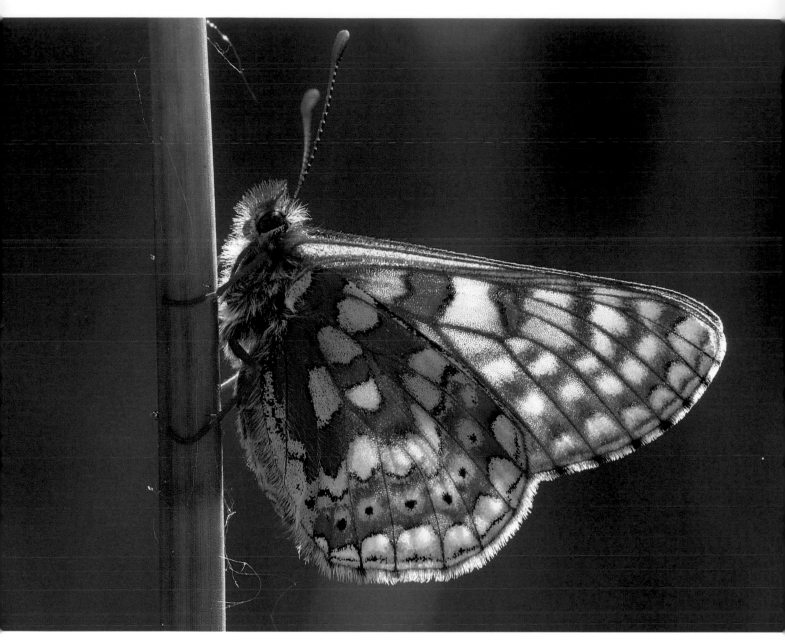

BACKLIT BUTTERFLY
Close-up and macro shots can open up new worlds as you home in on details
normally invisible to the unaided eye. This brings problems for composition and
focus as well as exposure. Photographer Ross Hoddinott has mastered these and
delivered this stunning shot in adverse conditions. Careful metering from the thin,
translucent wings of the butterfly has captured their almost luminous nature in
this lighting, but has also retained the overall lighting of the scene. When shooting
in close-up, focus is critical but by the same token rendering the background out-
of-focus helps further emphasize the subject.

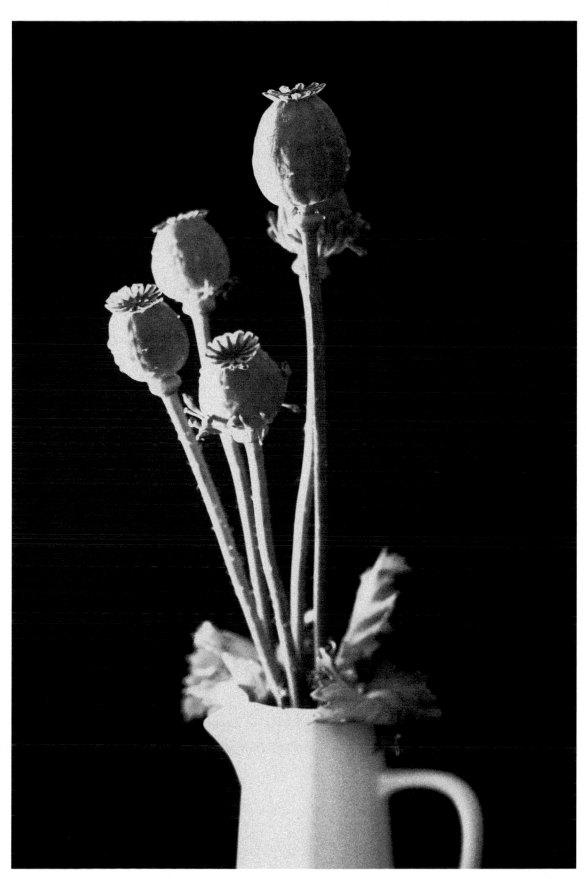

PAPAVER POPPY SEED HEADS
Careful lighting combined with precise exposure can emphasize the shape, form and colour in an image. In this image the lighting has been configured to strongly sidelight the subject. This accentuates the subject's shape and also renders the background dark, increasing the contrast between it and the subject. An exposure reading has been taken from the nearest seed head.

CHAPTER 3:
THE MECHANICS OF
EXPOSURE CONTROL

When William Fox Talbot, often credited as the father of modern photography, took his seminal shot of the oriel window at Lacock Abbey in the 1840s, his consideration of exposure was probably limited to thinking, 'should I expose this for one hour or two?' Whatever he opted for, subsequent shots were undoubtedly correlated to the results of the first and exposure control was, if not born, quantified.

After his early experiments, which were more focused on proving a principle than delivering an authentic image, it became clear that exposure would be a critical factor in photography. Measuring both the quantity and the quality of light became increasingly important as photography developed. The need for accurate exposure became particularly marked when colour photography appeared. Colour emulsions had less latitude, so accuracy became essential.

Before you can configure your camera for an exposure you will need to know how much light is falling on your chosen scene. You will also need to know how the scene – and the subjects within it – respond to the incident light.

BUDDHIST TEMPLE
Scenes like this succeed due to an accurate exposure setting.
The wide range of lighting, reflective subjects and colour make it
crucial that you identify the correct area to meter from (and make
corrections where necessary) in order to get the best image.

METERING LIGHT

You can establish an optimum exposure for any photograph in one of two ways. You can measure either the light reflected from a subject or the light falling upon it. Measurements based on the former are described as 'reflected' light measurements and the latter 'incident' light measurements.

REFLECTED LIGHT

This is the light that you observe all around you. Apart from the obvious exceptions of sources of light – the sun and artificial light sources – everything you can see around you is by virtue of receiving reflected light. For exposure purposes, all the conventional exposure meters built into cameras and many handheld meters, which you point at subjects to gain a light level reading, work by measuring the amount of reflected light.

Herein lies a problem – and it's a key one. The assumption needs to be made that a scene – no matter what it is – will always, on average, reflect approximately the same amount of light. The basis of these meters is that they are configured for making readings from scenes that have the same average reflectivity. This average reflectivity is often called mid-tone or 18 per cent grey reflectivity. Why? Because long ago it was established that a neutral grey surface that reflected 18 per cent of the light falling on it was a good representation of the reflectivity of average scenes.

Though this sounds somewhat arbitrary it actually works well. It forms the basis of the readings provided by almost every exposure meter in every camera currently available and, as you've probably discovered in your photography, it produces good results most of the time.

Note that I've said 'most of the time'. Your aim should be to get great results all of the time! An average reading may not be sufficiently precise to deliver spot-on exposure for many shots. Think of a shot comprising a snow-covered landscape, and another that features dark coalfields under a leaden sky. Obviously the reflectivity of each scene is fundamentally different, yet a basic reflected light meter would configure the camera on the assumption that each had an average reflectivity of 18 per cent. As your photography becomes more and more specialized – perhaps shooting subjects or scenes where light or dark tones predominate – average value exposure is no longer sufficient.

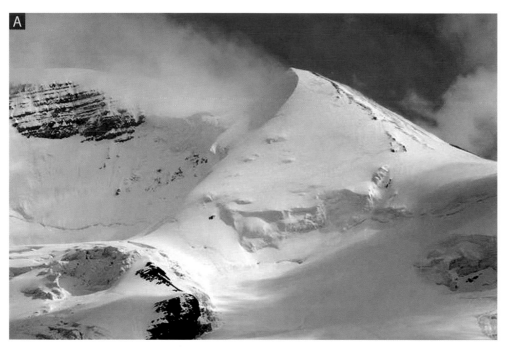

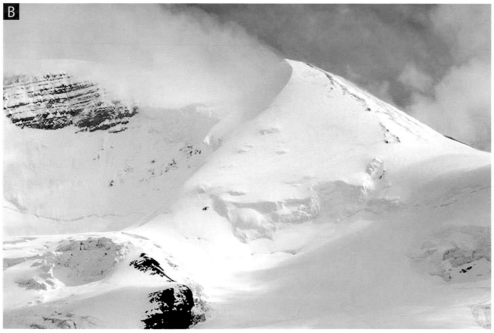

AVERAGED READINGS
Technically, the first image (A), made according to 18 per cent reflectivity, is the correct one. However, the preponderance of light tones requires that the exposure is increased to give a more flattering result (B).

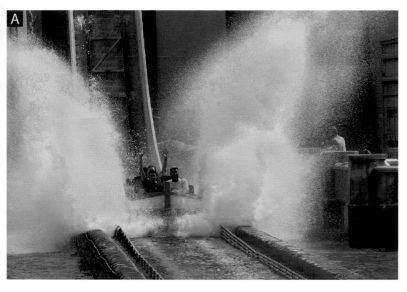

AVERAGE REFLECTIVITY

Where a subject has predominantly light tones – or white – average exposure readings will not produce an accurate exposure, as shown in the first image (A). In these circumstances, you would need to compensate for the tonality or take a reading based on the light falling on the subject (incident light) to produce a more balanced image (B).

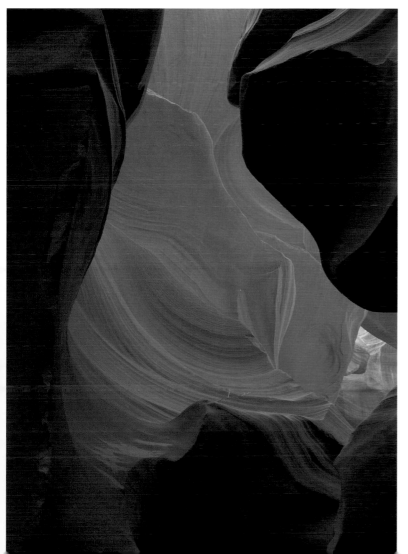

ANTELOPE CANYON

Created by the combined effects of water and wind, these sandstone canyons owe much of their beauty to the way light percolates in and is reflected around. In this shot, dark tones predominate and the photographer needed to take care in the exposure to prevent 'average' metering. This would have lost the delicate colouration.

INCIDENT LIGHT

No matter what the tones are in a scene, an accurate exposure for it can be determined by the amount of light falling upon it, known as the incident light. Even if there are several different elements within that scene, the light falling on each will be the same. If you base your exposure on the results from a meter that takes its readings from the light falling on a subject then you are less likely to be affected by the vagaries of reflectivity.

METER TYPES

All the digital cameras you are likely to own or use feature built-in metering of some description. This can vary from the basic, 'sufficient' system to something more comprehensive. At the most basic level they'll take a good stab at getting the exposure right in average circumstances. When the lighting gets a bit trickier they do tend to flounder a little. At the other end, more advanced cameras offer multiple modes that cater for exposures in virtually all situations – if you know how to interpret and exploit them.

Non-TTL meters

Compact cameras in general have exposure meters mounted on the camera body, but do not record light levels through the lens (TTL) (those rare models that do have TTL metering can be considered, for metering purposes, as SLR cameras). This gives the opportunity for taking a general reading – a rather crude average reading of the scene ahead of the camera. More sophisticated models use the better centre-weighted system, where sensitivity is biased towards the centre of the scene, as seen through the viewfinder. Some compacts also offer a spot-metering mode, where a reading can be taken from a small area at the centre of the frame.

TTL meters

Digital SLR cameras feature metering systems that measure the light actually entering the lens. As such they are reflected light meters and have all the benefits – and drawbacks – that we would associate with such a meter type (see table on page 40). Perhaps the greatest benefit in day-to-day use of a TTL meter is that it will automatically take account of lens type, lens setting and any filters that may be attached to the lens. This saves the photographer from having to calculate any exposure compensation, as would be the case with any form of non-TTL meter. When you look through the viewfinder of an SLR you'll be seeing the same view as the meter would see. Change that view – by changing the lens – and the meter sees the changes too. This is a terrific advantage – over non-TTL meters especially – and is the method used by default by the greatest majority of SLR camera users.

NON-TTL METER
External, non-TTL meters measure light levels via a window adjacent to the lens. It's important that this is not obscured (by a misplaced finger, for example), or erroneous results will be passed on to the metering system.

Technical tip

**METERING INFORMATION
IN THE VIEWFINDER**
If your SLR's metering system is only active when the shot is in progress (because it needs the mirror to lift first), how do you get exposure information in the viewfinder? Many cameras have a second exposure system mounted in or around the pentaprism that provides the preview data.

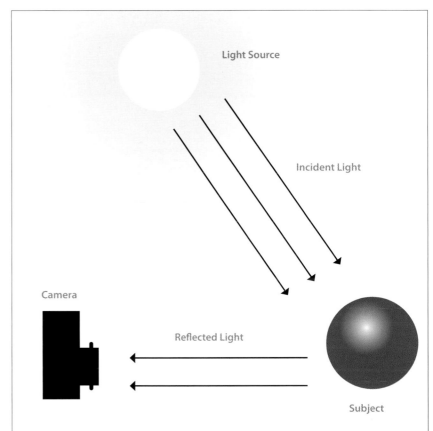

REFLECTED VS INCIDENT LIGHT
Measurements of reflected light are made from the standpoint of the camera and measure the light reflected towards the camera and meter. Incident readings measure only the light falling on the subject and so will not be affected by the reflectivity of the subject.

Metering systems

When the first breakthrough meter was introduced on an SLR it produced an average light reading for the entire viewfinder scene. Though the integration of metering was a tremendous advance, this was something of a backward step in metering accuracy compared with other (separate) meters available at the time. By the time digital SLRs debuted, metering systems had matured somewhat. Most digital SLRs then – as now – offer three metering types: centre-weighted, multi-segment and spot.

Centre-weighted

This is the basic metering system found in most cameras. The meter will read the light levels from the entire scene in the viewfinder but will bias the exposure value to the central area. A circular area of around one-third the height of the scene will contribute around 75 per cent of the reading. Some cameras offer flexible centre-weighted metering, which allows the size of the central circle and the bias amount to be varied using custom setting controls. Centre-weighted metering is best suited to portraits – where the face of the subject will tend to fill the central area – and landscapes where the principal subject is centrally positioned. Once the default metering system on SLRs, centre-weighted is now generally superseded by matrix metering.

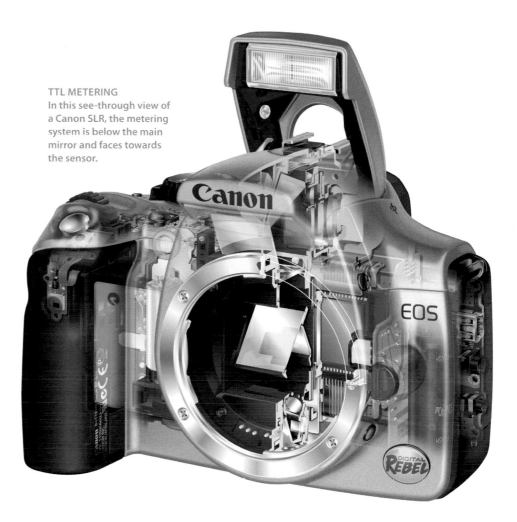

TTL METERING
In this see-through view of a Canon SLR, the metering system is below the main mirror and faces towards the sensor.

CENTRE-WEIGHTED METERING
The central circular area that contributes the main part of the exposure makes this mode particularly suited to portraits and landscapes, where the principal subject is often featured in, or metered from, this area.

Spot metering and partial metering

A method that pre-dates most other metering modes, spot metering retains its place on contemporary cameras on account of its effectiveness. Set this mode and the meter will read only the light levels from a small circle at the centre of the viewfinder (which, in many cameras, is marked by an engraving on the viewing screen) comprising around 3 per cent or less of the image. This makes it useful where the light intensities vary across the scene and you need to meter off a precise area.

Partial metering works on the same principle as spot metering but meters from a broader central area (around 9 per cent of the total image area). A few – but not all – SLRs feature partial metering.

Multi-segment

This type of metering system divides the viewfinder screen into a number of regions and takes readings from each. These readings can then be biased according to where they are in the scene and also according to any additional information that can be gleaned. For example, the Colour 3D metering system found on some Nikon DSLR cameras measures colour values, brightness and contrast and, when D-type AF Nikkor lenses are used, distance. The exposure system then compares the results with a library of actual shooting data (pre-programmed), amounting to some 30,000 possibilities. The result is potentially very accurate exposure.

SPOT METER
When it is important that a specific area of a scene or subject is critically exposed, spot metering delivers.

MULTI-SEGMENT METERING
Readings can be taken from each of the discrete areas – or combinations thereof – and compared with 'standard' pre-programmed scenes.

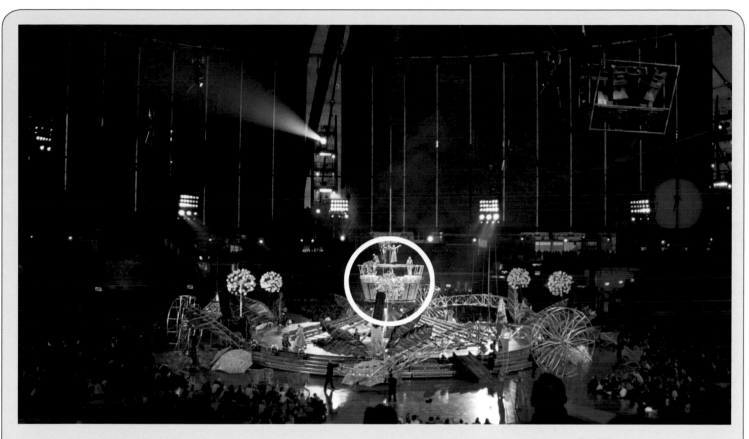

EXPOSURE LOCKING

Exposure modes such as spot metering offer very precise results – but only if the area you wish to meter is precisely under the 'spot'. If you don't want this part of the scene to be dead-centre in the image you can use the Exposure Lock feature. Once pressed, you can recompose your shot, with the original exposure settings retained. It's normally denoted by AE-L.

On some cameras you can press the Exposure Lock once and the exposure setting will be retained for the subsequent shot even when you release the button. On other cameras you need to keep the button depressed for as long as you need to retain the setting.

Conventional exposure modes would render this scene a mess, with a mid-grey background and overexposed subjects. By switching to spot mode you can meter off the central subject and then use the Exposure Lock to adjust your position to deliver a more symmetrical composition.

EXPOSURE LOCK
The Exposure Lock button (usually co-located with the metering mode selector) lets you use the exposure mode creatively prior to recomposing the scene.

IN-CAMERA (TTL) METERS

ADVANTAGES
- Convenience – built into and integrated with the camera.
- Automatically compensates for lenses fitted to camera along with any filters attached.
- Feature multiple modes to allow the best for each situation to be selected.

DISADVANTAGES
- Metering mode may not precisely match scene in viewfinder.
- Accuracy and precision may not be up to the level of handheld meters.
- Can be fooled into incorrect readings by some subjects and by the use of some filters.

HANDHELD METERS MEASURING INCIDENT LIGHT

ADVANTAGES
- Measures the light falling on the subject and hence uninfluenced by unusual reflectivity.
- Likely to give the most accurate of results when properly used.
- Incident light is stronger than reflected light, giving the chance of more accurate readings.

DISADVANTAGES
- Reading needs to be taken from close to the subject, which is not always feasible.
- Doesn't allow for filters or other light-attenuating accessories.
- More cumbersome than using an integrated (TTL) meter.

HANDHELD METERS MEASURING REFLECTED LIGHT

ADVANTAGES
- Some models can record the light reflected in a very tight cone (1 degree) for precise measurement.
- Potentially more precise than a TTL meter (which also measures reflected light).
- Convenient to corroborate TTL meter readings.

DISADVANTAGES
- Calibrated for 'average' scenes.
- Doesn't allow for filters or other light-attenuating accessories.
- Doesn't take into account reflectivity of elements within the scene.

UNDERWATER MODE
Shooting through water often produces an overall blue cast that would have masked the delicate yellow colours in this image had the photographer not selected the Underwater mode.

SCENE MODES

Given that some cameras boast a number of useful exposure modes, the additional scene settings can seem a case of gilding the lily. Are they really useful? Often the answer is yes. That's because, particularly when you're in a hurry, they provide a shortcut not only for getting good exposure results but also for configuring other aspects of the camera control – zoom ratio and flash settings, for example. Trouble is, some cameras boast so many scene modes that navigating them all can be a hassle. Nonetheless, here are some of the modes you might find on your camera and the benefits they bring. Do remember that not all cameras will feature all modes and this is not an exhaustive list.

Action – Chooses the fastest possible shutter speed to freeze subjects in motion.

Backlight – For when your subject is standing in front of a bright background and would, otherwise, be silhouetted. This setting will fire the camera's flash to give more even illumination.

Backlight 2 – Some cameras have an alternate backlight mode that overexposes (typically by 1 or 1.5 EV) to allow the subject to record properly, at the expense of the background.

Candlelight – Suppresses the flash and sets the colour balance to daylight to properly expose for candlelit scenes. Exposures are likely to be long, so it's important to support the camera properly.

Dusk & Dawn – Designed to optimize the shooting of sunsets and sunrises, mainly by underexposing to enhance the colour that would otherwise be lost.

Fireworks – Sets the focus to infinity, turns off the flash and sets a long exposure with medium aperture.

Landscape/Scenic – Sets the lens to a wide-angle setting, a small aperture and fixes the focus on infinity.

Night Scene/Night Portrait – Avoids underexposure in urban night scenes by setting a long exposure. For night scenes the focus is set at infinity; for portraits around 3m.

Portrait – Sets a medium lens focal length and a wide aperture/short exposure to throw the background out of focus.

Underwater – Compensates for the low light levels and bias towards blue in underwater shots.

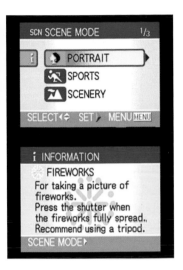

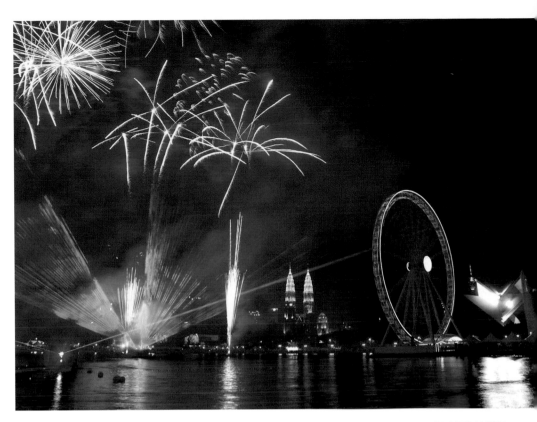

SCENE MODES
Access the scene modes either via the camera's command dial or, as here, the menu system. This compact camera also provides useful information on the selected mode.

FIREWORKS MODE
Fireworks – and in this case a laser light show too – can be problematic to shoot using conventional exposure modes. The dedicated Fireworks mode gets great results by setting the camera to infinity, choosing a moderate aperture and suppressing the flash.

CANDLELIGHT MODE
Set this mode to enhance – rather than obliterate – the gentle lighting produced by candles. Flashlighting would have totally ruined the mood of this image.

HANDHELD METERS

In a world where the TTL meter is so accurate and has the power to analyse scenes on your behalf why would you be bothered with a handheld meter? Far from being an anachronism, the handheld meter still has a useful role to play in that it can provide both accurate measurement and alternate measurement types to those in your camera. There are three types of handheld meter: that which measures incident light, that measuring reflected light, and that which can analyse colour. Some meters will fulfil just one of these roles, while others can manage multiple tasks.

HANDHELD INCIDENT LIGHT METERS

Incident light meters are often characterized by a white dome (called an invercone), which diffuses the light falling on the meter before this is passed on to the meter's light cell. To use the meter you ideally need to be positioned close to the subject and need to direct the meter towards the camera. The cone will then assimilate incident light falling from all directions.

The benefit of incident light meters is that they record incident light and therefore are not confused by high-contrast areas in the subject (or its environs). This achieves far more consistency between shots. Because of this you'll still find them used extensively by, for example, wedding photographers. It's important in shooting weddings that the bride's white dress doesn't adversely affect the exposure. By measuring the incident light you can achieve an objective exposure value and the photographer can deliver some stunning results.

Moviemakers also make widespread use of the incident meter on account of the consistency – crucial when shooting different scenes that demand reliable exposure.

HANDHELD REFLECTED LIGHT METERS

Even if your camera boasts a TTL meter, a reflected light meter will offer the opportunity to make more precise and specific readings than can be achieved by the camera meter. Though the in-camera meter is undoubtedly a precision device, there is some degree of compromise required to shoehorn the meter into the camera body and within its optical train.

Handheld reflected light meters offer general light readings and will often also feature a spot-metering mode. This offers much more precise reading capabilities, often able to record an area of the scene that subtends just a single degree – an order of magnitude more precise than a camera can muster. This precision makes them ideal for isolating, say, a single face in a crowd, or a performer on a distant stage.

Like all external meters you do have to remember that the meter takes a 'bare' reading. It doesn't take into account any filters or other light-attenuating accessories you may be using on your camera.

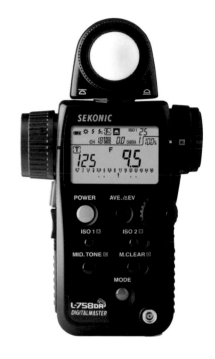

DIGITAL CAMERA METER
This meter (the L-758DR from Sekonic) is specially designed for digital cameras. It can be configured and programmed to respond in exactly the same way as selected SLRs. It also takes incident, reflected and flash light readings. The invercone for incident light readings is clearly visible at the top.

COLOUR METERS

Performing a task not found in cameras' metering systems, the colour meter is used to measure the precise colour temperature (see page 50) of light sources. The output of the meter is a reading that gives an objective colour reading and may also advise the best correction filters to be used to match the white balance set on the camera. Though white balancing can be done in-camera, or remedially using software, the use of a colour meter is often considered essential where a specific light source (among many in the frame) needs to be determined as neutral.

LIGHT METER
A simple handheld meter such as this can measure incident light using the sensor beneath the dome or, by sliding that dome aside, reflected light too. Attaching a PC flash cord to the connector at the bottom of the unit transforms it into a flash meter, for measuring multiple flash exposures.

EXTRA TOOLS

The exposure meter – whether in the camera or a separate handheld model – is a crucial element of your exposure determination. Mastering your metering system will pay a big part in achieving those perfectly exposed shots. However, you may want to equip your kit bag with a few more tools to increase your precision further.

GREY CARD

Meters, as we noted earlier, are calibrated so that they deliver an accurate reading when faced with a subject or scene that reflects mid-tone values – an 18 per cent reflectivity. If your scene doesn't contain areas that you can unambiguously describe as mid-tone, you will either have to guess the exposure (not something that is advised) or you can resort to using an 18 per cent grey card. These are available from photo stores either in the traditional form of a rigid card or as a more convenient collapsible screen.

It's not always easy to use a grey card (think of action photography or with backlit subjects), and getting good results does need a little practice (to ensure that you don't get reflections from the card's surface, for example). However, it certainly beats guessing, no matter how inspired that guess might be.

GREY CARD
For unusual exposure situations (such as this tabletop studio set-up), a grey card can be particularly useful in getting spot-on exposures where conventional metering may be fooled or pushed to the limits.

EXPODISC

This proprietary device comprises a filter-like disc that attaches to the camera lens in the same way as a filter. Unlike a conventional filter, its surface is covered with light-collecting prisms that can collect light from a full 180 degrees in front of the camera.

The Expodisc overcomes the frustrating problem that photographers sometimes encounter when using auto white balance (AWB). The biased results that are often produced deliver colour casts that can be difficult, if not impossible, to negate.

The benefit of the Expodisc is that it overcomes the need to use a more cumbersome grey card and uses the camera's built-in custom white balance (CWB) controls to convert the camera into an incident light colour meter.

To use it, you attach it to the lens (the same lens as you would use to take the ensuing shots) and aim the camera towards the principle light source – much in the same way that you would direct the invercone of an incident light meter – then take a CWB reading.

CALIBRATING YOUR METER

Photographers take a lot on trust with exposure meters. Not least that the results they offer will be accurate. But is this justified? On the whole, yes. Light meters today are very accurate and tend to maintain that accuracy. It makes sense though to qualify your trust by periodically testing your meter for accuracy. You can do so by running a simple calibration check periodically using an 18 per cent grey card – or something of equivalent reflectivity. Details of the best calibration method are included with your light meter.

This is also a good way to check, if you use a handheld meter, that it and the camera's TTL meter are delivering similar (if not identical) readings. In fact, many photographers use a simple check between their handheld meter and that of the camera when shooting similar subjects (notionally the hard-working grey card) to confirm the accuracy of each. If they are within 1/3 EV of each other, both are OK; if not, a more thorough calibration is called for.

EXPODISC

The Expodisc is arguably the simplest way to set a neutral colour balance on your digital camera. A Warm Balance version of the disc uses a subtle colouration to ensure that portraits retain a slightly warm colour balance. For the first image (A), the camera's own metering system (a matrix metering system) was used to get the best exposure. For the second shot (B), an Expodisc was fitted to the lens first and the meter reading taken with the disc in place. This reading was set on the camera and the exposure made when the disc was removed. Although subtle, the Expodisc achieves better exposure, particularly of the skin tones.

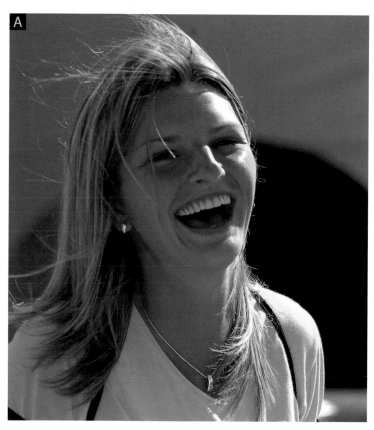

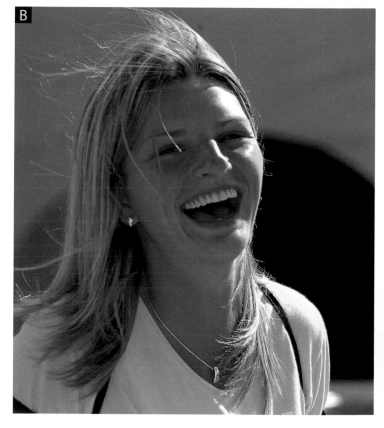

HISTOGRAMS AND EXPOSURE

The importance of the exposure meter cannot be doubted, but with the growth of digital photography another tool – albeit a less tangible one – has assumed similar importance: the histogram. Reviewing the histogram along with the post-view image can reveal crucial information about quality and provide clues to the efficacy of the image.

If you have used image-manipulation software you may well have encountered the histogram already. It can be viewed by selecting Histogram but is more likely to be seen in the Levels dialog box. An increasing number of cameras now also offer a histogram display, emphasizing its importance in exposure assessment.

So what does this histogram represent? To put it simply, it's a graph that represents the maximum range of light levels that the camera can capture. It is measured in 256 steps or levels, where 0 is pure black and 255 is pure white. The central part of the graph represents the mid-tones. The height of the graph at a particular level shows how much of that particular tone is in the image. If the graph shows no levels for specific tones there are no sections of the image with that tonality. Why are we so interested in the histogram? Because the sensor in your camera can't accurately record the full range of brightness in many scenes; it can only successfully record a limited range of EVs. By displaying a histogram you can unambiguously determine the brightness range in any scene.

AVERAGE HISTOGRAM
The histogram for an average subject shows data throughout the brightness range, with the peak in the central mid-tones area. Only to the left of the histogram is there no data – which indicates a lack of true blacks in the image.

GOOD HISTOGRAM, BAD HISTOGRAM?

In truth, there's no such thing as a good or bad histogram. A histogram is merely a representation of components in an image and, as such, is just showing things as they are.

A typical histogram might be like that shown on page 45. It shows a distribution of levels throughout most of the range, with the bulk, as you might expect for an 'average' subject, occurring in the central, mid-tone area. The absence of levels at the extreme ends of the scale shows that there are no true blacks recorded – as you might anticipate when you examine the image. You can correct this – if you wanted (or needed) to with the Levels command when you come to process the image.

In some images – snow scenes for example – bright tones predominate. The levels – and particularly the peak in the histogram curve – will tend to be bunched up towards the right of the graph. Conversely, for darker scenes you will have a histogram that is biased towards the darker levels.

Interpreting a histogram

The night scene shown below produces a histogram that is biased (again, as you would expect) towards the darker tones. Particular points to note include the peak to the right, which represents the bright lighthouse beam. The fact that this is firmly positioned at the extreme right suggests that it is overexposed (although, for a light source, this would be considered OK). The lack of levels to the extreme left shows there are no true blacks. This is something you may choose to correct using image-manipulation software.

In the second example – the bright image opposite – again, there are no true blacks, but also no adjacent dark tones. Tones are crammed towards the right-hand end, showing that the bright areas of the scene are overexposed.

NIGHT HISTOGRAM
The domination of dark tones in night shots is reflected in the histogram, which peaks in the lighter tones due to discrete light sources.

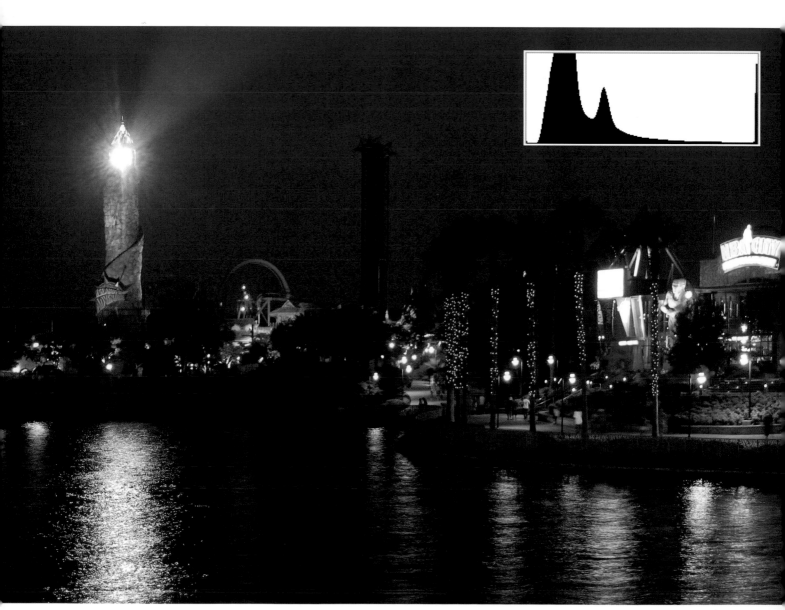

An examination of the image itself confirms these suspicions that the photographer, probably in an effort to avoid underexposure (from the large bright areas) has overcompensated and overexposed. Had you examined the image itself on the camera's LCD panel you would probably not have been aware of this; fortunately, the histogram would have come to your aid and allowed you a second-chance shot.

BRIGHT HISTOGRAM
In this case there are no true dark tones in the image, betrayed by the lack of data to the left of the graph.

HISTOGRAM DISPLAYS
Though small (necessarily, given the size of many camera LCD monitors), the histogram is of sufficient size to make an objective assessment. The representation of histograms on cameras varies according to manufacturer and by model.

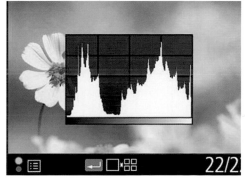

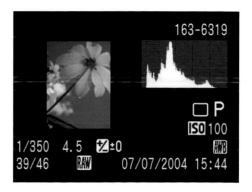

CHAPTER 4:
EXPLORING LIGHT

Light is the crucial factor in exposure, and the intensity of light is fundamental.
However, there is more to light as it is used in photography than quantity.
To understand exposure, you also need to understand the quality of light and
how cameras interpret it. In studying light in photography you need to take
into account both the objective nature (which you can equate to the amount
of light) and the subjective nature of light. The nature of the disparate range of
light sources that might illuminate your images can vary enormously: think of the
intense light of midday through to the merest glow of a candle.

Light sources also vary in colour. In many cases this is obvious, although you
may not explicitly quantify that variation. You might talk about some sources –
such as candlelight and the last hour of daylight – as being 'warm'. In fact, there is
much more variation in the quality and colour of light and your camera is only
too adept at highlighting every nuance.

This chapter explores the ways that you need to see and appreciate colour
in order to become competent in exposure control. It will examine the technical
basis for describing light and colour; the ways a camera handles variation, and
also the bearing that your own interpretation will bring, in that quest to capture
better photographs.

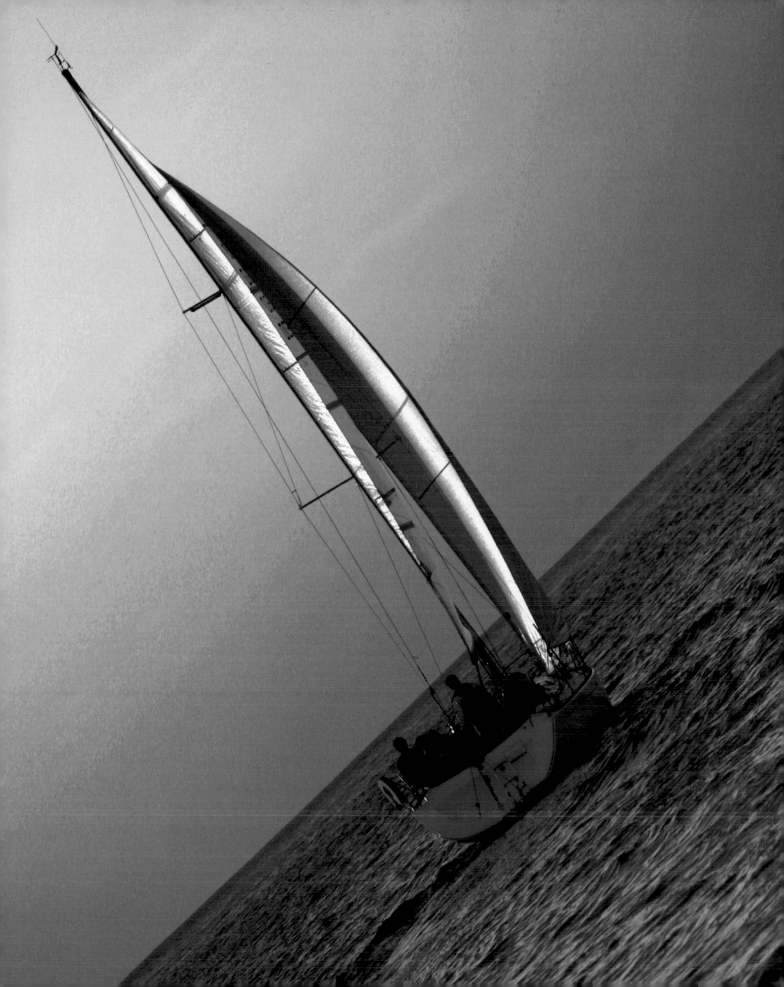

COLOUR TEMPERATURE

The human eye is a remarkable device, and has an amazing ability to interpret the world around it. Move from bright daylight in to a dark interior, or from rooms lit with fluorescent bulbs through to those lit with candles and (assuming your eyesight is unimpaired) the eye compensates for every tiny change in luminosity, colour and hue. Not so the sensor of your digital camera. Sensors are much more objective about the colour of scenes and will record colours that, while technically accurate, will not always be what the photographer intended to portray in the final image.

The variation in objectively recorded colour can be described by the term 'colour temperature'. Colour temperature represents all light sources as a temperature along a scale that ranges from deep red for 'cool' light sources such as glowing fires and candles, through the oranges of traditional light bulbs and on to the brighter, hotter whites and blues of sunlight, halogen bulbs and clear skies.

Photographically, there's something of an incongruity with this scale, one that those with a knowledge of the underlying physics will instantly recognize. Light sources with a high colour temperature (blue) are, in photographic terms, regarded as cool, while those with a low colour temperature (such as sunrise or sunset) are considered warm. For that reason, It's best to consider the colour temperature scale as a colour scale and not a temperature scale.

The basis of the scale for the photographer is average noon daylight – the light you might get on a sunny day around midday. This is defined as 5500K (the unit is Kelvin and not, as many describe it, degrees Kelvin). This is essentially neutral in terms of colour and is the setting to which your camera's sensor is set. (It is also that to which traditional daylight films were balanced.) Shoot a scene lit by sources that have a lower Kelvin temperature than this and you risk an increasing warm, reddish colour cast, and with a higher Kelvin, a cooler, bluish cast.

CORRECTING COLOUR CASTS

Of course, the best way to correct a colour cast is to ensure that you don't record one in the first place. That means adjusting the camera's white balance (see pages 52–55) to ensure that there is a neutral balance from the outset.

WARM AND COOL LIGHTING
The warmth – or cold – imparted by lighting can make a dramatic difference to your images. The effective lighting of this scene has been modified to demonstrate the difference between warm (A) and cool lighting (B). Which is best? We instinctively get drawn to the warmer scene, but often the best lighting is not the same as the most accurate. In this comparison, the cooler image is that which the camera delivered; the warm one was achieved by a little digital manipulation.

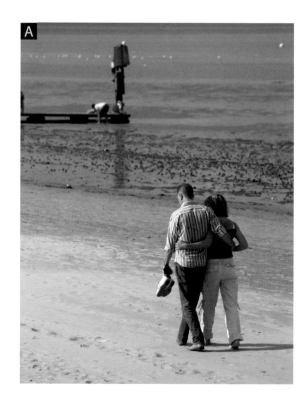

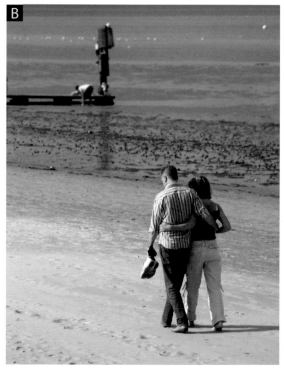

| 9000 | 8000 | 7000 | 6000 |

If you've recorded your image in RAW format, no white balance information will have been recorded and you can make the correction using your RAW processing software. Other image file formats will retain a cast as dictated by the colour temperature of the light source, and this can be corrected using image-manipulation software. The proviso should be made that such corrections will always be second best to in-camera or RAW white balance corrections.

Difficulties arise when you have mixed lighting sources. Then any correction applied to compensate for one lighting source will have a detrimental effect on others, perhaps exacerbating the cast produced by those sources. In such cases and where the mixed lighting is a problem, you must resort to digital colour correction techniques to reduce (or enhance) specific colour casts.

Technical tip

WHAT'S IT ALL ABOUT?
If you want to know how the Kelvin colour temperature scale is absolutely defined, it's all down to a black body radiator. In physics, this is a theoretical body that radiates the energy supplied to it. As you provide more and more energy – by heating it up – it radiates that energy first as heat and then, as the energy increases, light. The colour of that light is dependent on the temperature it has been heated to and is the foundation of the colour temperature scale.

COLOUR TEMPERATURE
Throughout the day, around the world, the colour temperature of your shots can vary widely – and the results are all the better for it.

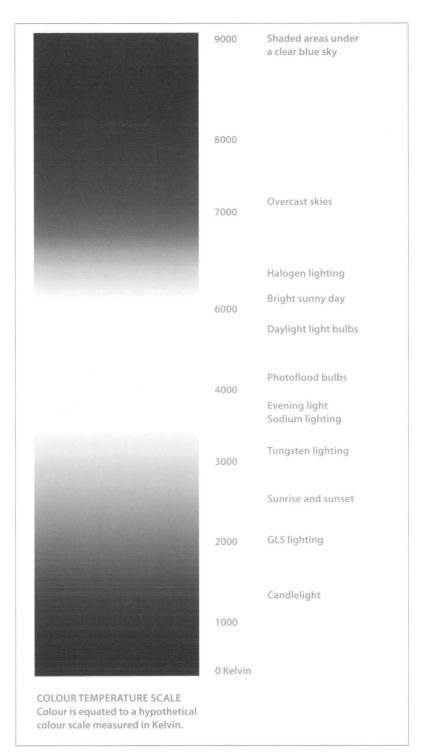

9000 — Shaded areas under a clear blue sky

8000

7000 — Overcast skies

Halogen lighting

Bright sunny day

6000

Daylight light bulbs

Photoflood bulbs

4000

Evening light
Sodium lighting

Tungsten lighting

3000

Sunrise and sunset

2000 — GLS lighting

Candlelight

1000

0 Kelvin

COLOUR TEMPERATURE SCALE
Colour is equated to a hypothetical colour scale measured in Kelvin.

3000 2000 1000 0 Kelvin

UNDERSTANDING WHITE BALANCE

As a photographer, the tint imparted by light sources of a particular colour temperature may be important to your photographs. You may want a warm glow in a candlelit scene or a vibrant, cold blue for your snow scenes. But there will probably be a greater number of instances when you want to negate any colour cast and produce a neutral image.

Technical tip

WHITE BALANCE AND RAW IMAGES
If you choose to record your images in the RAW format (see page 60), white balance corrections are not applied to the image. You are free to set whatever balance will best suit that image.

If you have graduated to digital photography from conventional film-based cameras, you'll probably recall that there were two key types of film stock: daylight-balanced and artificial-balanced. You could use one type of film with the other lighting source but would need to use a raft of colour-correction filters to prevent colour casts. If you chose not to use those filters, shooting indoors using a film balanced for outdoor use would result in images with a strong orange/amber cast. In the digital age, colour-correction filters have been replaced by a single, simple feature that adorns even the most basic of digital cameras – white balance.

In the examination of colour temperature (see page 50) I mentioned how some lighting sources (such as the tungsten lighting that is standard in many houses) produce warm lighting tending towards oranges and reds, while others are more neutral or even cool – tending towards a blue tint. Colour-correction filters would neutralize the respective cast to render the scene more neutral, but never totally so (unless you resorted to using a colour meter and specialized colour-compensation filters). With digital cameras you can ensure, even if your lighting scheme is complex, that you can effectively shoot images that are, in colour cast terms, neutral.

The principle of the white balance control is simple: you tell the camera which component of the scene should be white (or, at least, neutral) and the camera will determine the difference between this and true neutral. It will then adjust all the colours in the scene by a corresponding amount.

COLOUR BALANCE
With the camera's white balance switched to Tungsten (for indoor lighting) this shot (A) was taken outdoors where the setting should have been Sunny or, at least, Auto. The blue cast due to the incorrect setting is obvious. With the white balance set correctly, the colour cast is removed (B). The colour balance is now neutral; this is most obvious in the green areas of the shot.

IN-CAMERA WHITE BALANCE CONTROLS

Depending on the camera, you will have up to three different options for white balance control: Auto, Manual and Pre-set.

Auto white balance automatically determines the white balance continuously and will use the camera's best determination at the time of exposure. This is good for general shooting (and where light sources are mixed and not catered for by pre-sets) but can sometimes lead to inconsistent results between images shot in quick succession with slightly different scenery.

Pre-set white balance offers pre-sets for standard lighting conditions such as Sunny, Cloudy, Tungsten and Fluorescent. Switch to one of these if you are shooting predominantly under one lighting source.

Manual white balance lets you set a white balance based on a neutral element in a scene or (if you've brought one with you) an 18 per cent neutral grey card. This card is discussed more on page 43 as it's also useful for calibrating your camera's light meter.

AUTO WHITE BALANCE SENSING
Most cameras evaluate white balance using the output from the image sensor. Some cameras, such as the Olympus E1, use a hybrid system. The small window conceals a colour sensor that evaluates the average colour of the scene and compares it with the CCD white balance. The sensor, placed behind a translucent window, works in a similar way to the invercone on an incident light meter (see page 42), assimilating incident light, and thereby providing an advanced white balancing correction.

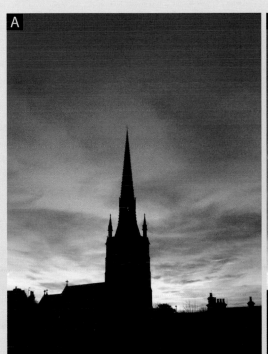
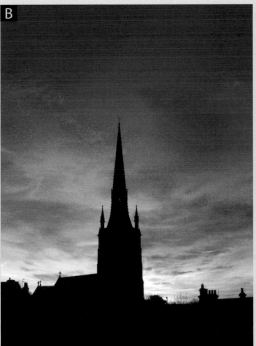
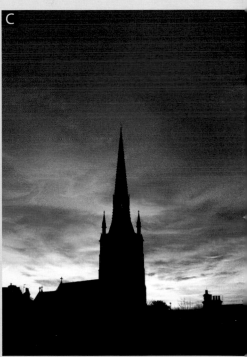

EMPHASIZING CASTS
A creative photographer will not always want to neutralize a colour cast. Think of a vivid sunset: white balancing will render colours pale against a greyish sky. In these situations you may want to set the white balance to a specific lighting type to enhance or even exaggerate a cast. For a sunset you might set the pre-set to that of an overcast sky (to emphasize the reds); to give a warm look to interiors, select a daylight setting.

ENHANCED CASTS
The sky here has been shot using Auto white balance (A) and Sunny (B). For the final shot (C), a warm 81C filter has been simulated in Photoshop (see page 55) to add a further amber cast.

WHITE BALANCE SETTINGS

Two scenes, six different settings. These scenes have been shot using different white balance settings, including Auto (so, essentially the camera determines the best) and Manual (where the setting was made by reference to a grey card). In some cases the differences are very subtle, in other cases more marked. Which is the best setting for these images? That is not as obvious as it might seem. The technically accurate settings would be the Manual in both cases. However, it is the Tungsten setting that gives the best rendition of the flower and Sunny for the street scene. You should bear in mind that technical accuracy and perceived accuracy can sometimes be quite different. This is why, increasingly, photographers prefer to work with RAW images and make corrections on the unadulterated (in white balance terms) images rather than further correct an image to which a correction has already been applied.

AUTO

MANUAL

SUNNY

CLOUDY

TUNGSTEN

FLUORESCENT

CORRECTIONS FOR DIFFERENT LIGHTING TYPES

The white balance corrections for different lighting types seem, for the most part, self-explanatory. However, there can be some anomalies due to the actual colour or tint of the lighting. In the table right is a run-down of key lighting conditions along with the traditional photographic filter type that provides an equivalent correction.

Why should you be bothered with these filters, when you can circumvent the problem in camera, or using software? Well, the camera's auto white balance may be set incorrectly or not set at all. So, when you download your images to your computer, the image-manipulation applications allow you to apply photographic filters retrospectively. You'll be able to apply the digital equivalent of each of these filters. This may be particularly important when you save (or use) RAW image files to which no white balance modification has been made. Finally, white balance corrections are not always as precise as corrections that can be made using any of the broad range of digital filters available.

It should also be noted that there is some variation between different cameras – and camera models – when it comes to white balance settings, so you may find that for a precise correction you need to vary the filtration used.

DIGITAL FILTER/WHITE BALANCE EQUIVALENTS

Illumination	White Balance	Filter
Sunlight at noon	Cloudy	81B
Blue sky, no clouds	Cloudy	85A
Sunny day, some clouds	Sunny	None
Sunny day, in the shade	Shade	81C
Overcast	Cloudy	81B
Mid-morning/afternoon daylight, some clouds	Cloudy/Shade	81A
Morning, after sunrise, afternoon prior to sunset	Cloudy	81A
1 hour before sunset, 1 hour after sunrise	Shade	81A
Sunset	None*	None*
Electronic flash	Flash	None
GLS lighting (tungsten bulbs, 100W)	Tungsten	80A
Energy saver bulbs**	Fluorescent	82C
Fluorescent**	Fluorescent	82C
Tungsten photo bulbs	Tungsten	80A
Candlelight	Tungsten	80A

* Depends on colouration: the intention at sunset is to capture the colour of the sunset and so filtration or colour correction may be applied to enhance this.

**The spectrum of these bulbs can vary according to type and manufacturer; the values quoted here represent an average value appropriate to the most common types.

DIGITAL PHOTO FILTERS

Photoshop has long boasted a wide array of filter effects but curiously it was not until version 7 that it added a set of filters that emulated photographic filters. You can now find these by selecting Image > Adjustments > Photo Filters. The Photo Filter dialog box allows you to choose any of a selection of 'real' photographic filters or, by clicking on the colour button, any colour from the colour palette. You can also vary the strength using the Density slider. If you keep the Preserve Luminosity box ticked the overall luminosity of the image will not be affected by the filter application. This is similar to the effect of a real filter, which will modify the exposure to compensate for the filter density.

PHOTOSHOP FILTERS
The Photo Filter dialog box in Photoshop.

CHAPTER 5:
SHOOTING GREAT PHOTOS

Taking successful meter readings – that's what good exposure practice is all about. Getting the correct exposure for your image depends on several factors. Some of these are mechanical: the angle of the light and the way the metering system measures that light. Others are more artistic and creative: your interpretation of the scene and the vision you have in mind. The previous chapters have looked at the mechanics of metering and how the nature of light can affect the results. Now it's time to look more closely at how you can consolidate this knowledge to help gain control of exposure – to have the light and the camera work for you.

When can you take your exposure meter's output as an accurate reflection (no pun intended) of the lighting in a scene? How can you vary the indicated exposure (through compensation or adding accessory equipment) to achieve the best result? How can you realize the scene in your mind's eye from that currently in the viewfinder? These are just some of the issues that you need to be mindful of and that will be explored through this chapter.

COASTLINE AT SUNSET
This scene is lit both directly from the setting sun and the sunlight reflected from the clouds. Careful assessment of the exposure was essential to ensure that the colour in the clouds and, more significantly, the colouration of the foreground rocks was retained. The photographer metered from the bright clouds and then reduced the exposure by 1 EV.

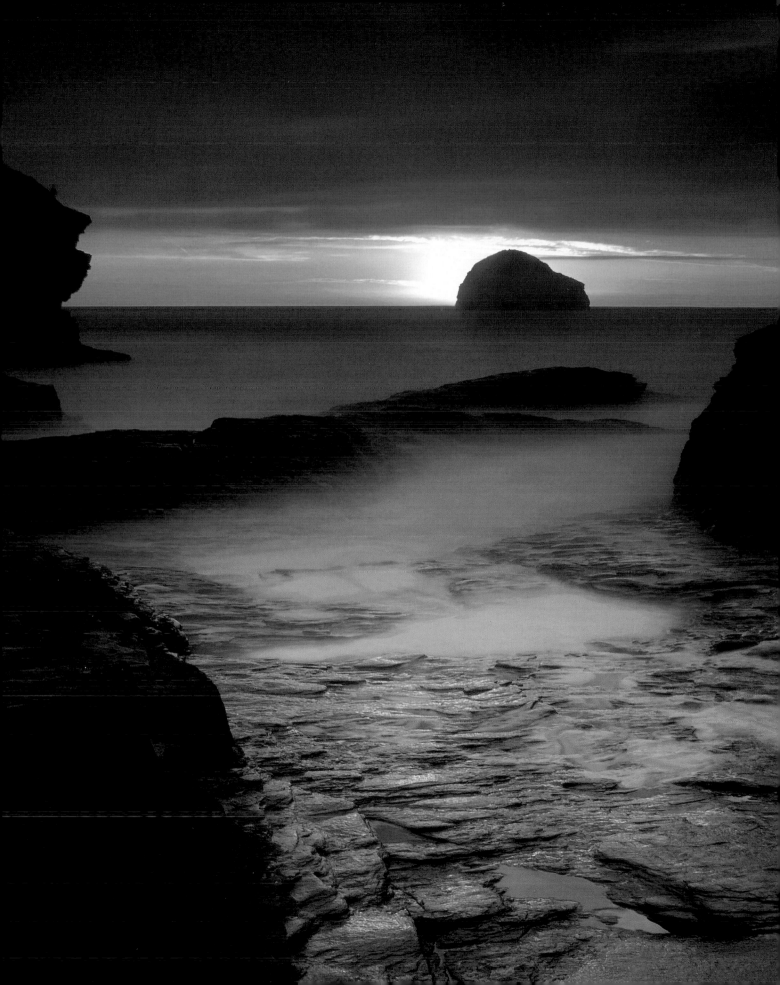

THE SUNNY 16 RULE

Let's begin by taking a look at one of those professional's secrets that eschews much of the technology that is normally associated with metering exposure. It's no replacement for good exposure measuring technique but it could one day be a photographic lifesaver.

Of all the components that go to make up a camera it's the exposure metering system that has had the most number of man hours devoted to it. The result, as you have seen (and as you see in most photos that you shoot) is a component that is remarkably accurate no matter how extreme the conditions you throw at it. It can be surprising then to learn that many professional photographers ignore the meter for many shots and resort to a rule that smacks of imprecision. It's called the 'Sunny 16 Rule' and it can be a great way to (almost) guarantee perfect shots when you don't have – or don't trust – your meter.

The rule applies from around two hours after sunrise to around two hours before sunset. Assuming you have a clear sunny sky, free of haze or pollution, you can set the exposure as follows.

set the aperture to f/16, the camera sensitivity to ISO 100, and the shutter speed reciprocal to the sensitivity – that is 1/100sec (or 1/125sec as it appears on most cameras).

The Sunny 16 Rule can be applied anywhere in the world. Though it is designed to be applied to subjects that are frontlit it can also be applied to those subjects that are sidelit. Normally, in such cases you would open the aperture up by half a stop to compensate. Or, as is wise when you're not totally sure of the correct exposure, bracket your exposures (see page 62). It's not perfect, but the rule is a great fallback.

A note of caution: the display on the camera's LCD monitor is a good, but not perfect, guide to the exposure. The Sunny 16 Rule is actually a more accurate way of getting a good exposure.

(see page 62)

Pro tip

VARIATIONS ON A THEME
The Sunny 16 Rule is useful in bright weather, but what if the weather conditions are not perfectly sunny? You can extend the rule as shown here, opening the aperture as the light levels fall.

Aperture	Sky condition
f/16	Clear, sunny
f/11	Hazy, light overcast
f/8	Overcast
f/5.6	Heavy overcast

SUNNY 16
Despite using a manual exposure calculation (according to the rule), this shot manages to successfully capture the detail in the highlights (the white ruff around Harlequin's neck) and the shadow detail (the doorway).

THE SUNNY 16 RULE AND DEPTH OF FIELD

You don't have to use f/16 if you want to take advantage of the Sunny 16 Rule. If you want to modify the depth of field by using different apertures here are the corresponding settings. This relates to a camera ISO setting of 100 and bright, sunny conditions.

Aperture	Shutter speed
f/5.6	1/1000sec
f/8	1/500sec
f/11	1/250sec
f/16	1/125sec
f/22	1/60sec
f/28	1/30sec
f/32	1/15sec

Of course, you can also vary the sensitivity and vary the other parameters accordingly (at ISO 200, the best shutter speed will be 1/200sec).

MODIFYING THE RULE
For this shot, also in full sun, it was important to get the depth of field shallower than I would have had I stuck with f/16 (that would have rendered the water in the background sharp too). Also, with the lighting ostensibly from the side, I needed to make a half-stop compensation. Hence the exposure settings were f/5.6 at 1/750sec.

HOW IT ALL BEGAN
Photographers picked up on the Sunny 16 Rule back in the 1930s when light meters were not in widespread use. Even when meters began to appear in the marketplace they did tend to be inaccurate and comparing the readings with those suggested by the Sunny 16 Rule became a popular calibration and adjustment method.

HERON AT SUNSET
Though shot at sunset, this image follows the Sunny 16 Rule. By following the rule in this case the photographer has delivered a perfect silhouette of the heron framed by a well-saturated sunset.

SHOOTING RAW IMAGES

Whether armed with your metering skills or opting for the Sunny 16 Rule (see page 58), you'll need to make some decisions about how to shoot your images. The first, and perhaps most profound, is the format in which you'll record your photos. Do you go for the camera's virtual default, JPEG, or TIFF, or the less well understood RAW?

Shooting your images with the camera set to auto all the time will never make the best of your photographic situations. Similarly, the pros will say that to record your images in a format other than RAW is equally debilitating. So what exactly is RAW and why should you consider using it?

RAW, like JPEG and TIFF, is a format used to record image files from digital cameras. Unlike JPEG and TIFF, both of which process the image in various ways (not least, in the case of JPEG, by introducing substantial compression), the RAW format stores, as far as is feasible, the raw, unprocessed signal as it comes from the camera's imaging sensor.

It's easiest to see the significance of this if you make a comparison with film-based photographs. A RAW image is the digital equivalent of the negative, and the conventional JPEG or TIFF image is the print you receive from that negative if you take it to a photo-processing lab. What is the difference? The print that you get from the photo lab has been produced from the original negative but in that production the processing equipment will have adjusted the colour, contrast and tone to conform to settings that it – the lab – considers standard for a print. That's why those shots of bold sunsets and colourful Caribbean seascapes always turn out so much blander than you remember them – and blander than the data in the original negative should reveal.

When you shoot a digital image, the data that is produced from the sensor undergoes a similar transformation in the camera electronics. Colour, contrast and other values (including sharpness) are altered, ostensibly to make it easy for you, the photographer, to handle the image. Unfortunately, in doing so, some of the original – raw – data can be lost. A RAW image may not be much to look at in its raw state, but with just a little manipulation it can reveal an image quality – and allow exposure tolerance – that would be impossible from the processed image.

It does take a little skill to coax out the image detail and subtlety that exists in the RAW image, but for those shots that are problematic in terms of lighting or exposure, the time spent in doing so will be amply repaid.

Technical tip

DECODING RAW FILES

The RAW format is something of a misnomer; it is not a tightly specified format in the same way that TIFF or JPEG file formats are. This means that not all applications will be able to decode all RAW formats. If you intend to shoot in RAW, make sure that your image-editing or processing application can accept the format. You may find that if your format is a more obscure one, the camera manufacturer may provide an appropriate application or solution for using the files more widely.

THE RAW FACTS

Though they are the key to the ultimate in digital image quality, there are both benefits and drawbacks to using the RAW format.

BENEFITS

- RAW is a lossless format; no data is sacrificed or lost when saving to the format (compare this with the lossy JPEG format, which discards significant amounts of data).
- RAW uses a higher bit depth. That means in practice that you can record more detail in the shadows and highlights and get smoother tones between.
- You have a huge amount of control with a RAW image; much more than conventional software or camera electronics can provide.
- A RAW image is independent of the camera settings. It bypasses controls such as white balance and sharpening so you can set any of these to your chosen values later. This gives you considerable freedom at the image-manipulation stage.

DRAWBACKS

- RAW files take up more memory space: you'll need more memory cards or greater capacity for the same number of images.
- RAW files take longer to write to the memory card – this may reduce the number of shots you can shoot consecutively and can increase waiting time between shots.
- Every image needs to be processed. A RAW image is – well, raw. It needs to be processed in software to bring out the best in it.
- Not all cameras display RAW images on the LCD after shooting, meaning you may have to take shots on trust.
- RAW file formats can vary from one camera to another and may not be readable or compatible with all image-editing software.

Should you shoot in RAW all the time? Take a lead from the pros: some will shoot only in RAW, while others reserve RAW mode for a more limited range of shots. It comes down to the importance you attach to a particular shot and, as you'll see later, how much control you need.

RAW IMAGES
Straight from the camera, a RAW image (A), can appear as something of a disappointment (particularly for difficultly lit subjects) and will lack the obvious punch of a JPEG or TIFF image. However, with a little manipulation you can extract more latent information from the RAW file to leave you with a much-improved shot (B).

EXPOSURE BRACKETING

The next decision you need to make is whether you can successfully record your image with a single shot at the exposure – determined by your meter, your camera or your skill – or whether you need to resort to taking some insurance shots too.

When you take a photo – any photo – you trust the camera's meter to configure the camera to give the best exposure. There may be some intervention, perhaps to change the shutter speed/aperture combination for creative reasons or to compensate for an over-bright or dull element in the scene. Whatever you do, you've taken on trust that the exposure suggested by the camera will be OK. Is that a fair presumption? On the whole, yes, but events – and more particularly scenes – can conspire to mislead the most competent of metering systems.

Professional photographers, especially those brought up using film, have long realized that to get the absolutely best shot it's unwise to rely on either the exposure system of the camera or

their own skills to provide anything other than a good approximation. And the more extreme the lighting in a shot, the more inexact that approximation becomes.

The solution? Trust neither camera nor self and bracket your exposures. Exposure bracketing

SUBTLE BRACKETING
A situation like this features extremes of shadow and highlight as well as substantial areas of intermediate tone. Here the photographer has bracketed using a difference of 1/3 EV between each. The result show that there is no 'right' shot (the nominally correct exposure is outlined in red) and this could be an opportunity to use additional techniques such as High Dynamic Range imaging (see page 74).

Technical tip

AUTO BRACKETING
Many digital cameras include an auto bracketing feature called AEB (auto exposure bracket). When this is selected the camera will automatically take one shot at which it perceives the correct exposure and additional shots over and under this. When you configure AEB you can specify the number of shots and also the exposure increment between each.

involves taking more than one shot of any scene, each with a different exposure value. In practice, this involves shooting once at the notionally 'correct' exposure and then taking another shot (or shots) under and over this value. The number of shots, and the amount of variation in exposure value between shots, will be determined by the subject and your confidence.

Back in the days of film (when every shot had a cost to it), most photographers tended to shy away from taking large numbers of bracketed shots. Only those shots with best pictorial (or commercial) value would command more. Now that shots take up space on your memory card rather than cost, you can be more profligate. Consider varying the exposure by 1/3 EV (1/3 stop) between shots for the ultimate in subtlety.

WHY BRACKET?

Bracketing can be important – crucial even – because often the camera's metering system may have been deceived by the light incident upon it. Camera manufacturers actually spend a great deal of time programming the metering system of a camera so that it can recognize many scenes and can then compare the suggested exposure with a reference. This is why cameras today are so expert at getting the exposure right much of the time. There will be times, however, that you have a scene that doesn't correspond with one of these references or your intention is to expose for a specific part of the image. Bracketing ensures that you cover all bases.

The question that you also need to ask is why bracket when your image-manipulation software can often correct exposure errors? While it is true to say that software can often correct exposure errors, it cannot always provide the necessary detail and gradation in shadow and highlight areas. No imaging software can make good highlights devoid of any image data due to overexposure, for example.

SUNSETS
The first shot (A) used centre-weighted metering to enable the sky and the landscape to contribute to the exposure calculation. The result is that the sky is rather lacklustre and any colour in it is washed out. Reducing the exposure by 1 EV, by halving the exposure time (B), enhances the colour and also provides more detail in the areas that were burned out in the first image. Underexposing by 2 EV makes a more profound difference (C). Though technically underexposed, this gives the best image of all three. Any further reduction in exposure would compromise the image brightness with too much of the image becoming murky.

WHEN TO BRACKET
Forget the advice some professionals offer to 'bracket every time'. They can usually afford the time and have the capacity in their memory card collection to do so. You should be more circumspect and should consider bracketing whenever the lighting is tricky, by which I mean if there is a preponderance of shadows or highlights, or when you know from experience that alternate exposures (compared with the standard) are usually more successful.

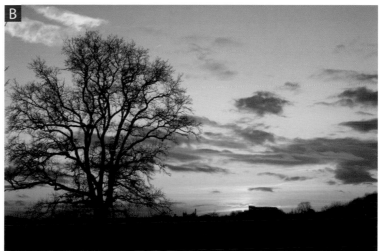

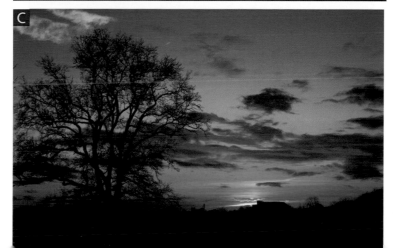

TAKING SUCCESSFUL METER READINGS

Hopefully by now you have a good idea of what is needed in terms of exposure when you go on a photo shoot. Now let's examine how you take successful meter readings that will, in turn, lead to equally successful images.

When a scene features a wide range of brightness levels and you need to record detail in both the brightest and the darkest parts, it calls for some considered use of the exposure controls. You need to make best use of the latitude in the camera's image sensor so that all significant parts in the image fall within its range.

Often this calls for assessing a median brightness level in the scene. Like the aspiring musician who must develop a keen ear for pitch and timbre, so the photographer needs to develop an acuity for brightness. With this skill – which is not especially difficult to master – you'll be able to assess a scene and identify how you should configure the exposure.

DIFFERENT RESULTS
Often an image that's reproduced from screen (A) to paper (B) looks darker and more contrasty. This is normal and appears similar to these examples (which is simulated as, of course, both images are reproduced here on paper). You may need to adjust the image digitally (by altering the midpoint level as described on page 102) to preserve details in some of the darker areas.

SCREEN VS PRINT
Many people are surprised at the difference between an image viewed on a computer screen and a print. Good colour management can ensure that colour authenticity is preserved, but you'll always experience a difference in brightness and apparent exposure range. On screen, images will always look brighter; prints, by nature of the medium, will appear to have a different contrast (the contrast ratio – between brightest and darkest areas – is lower on paper) and somewhat less bright. You may want to tweak the image settings on occasions to ensure you'll get the best from the printed image.

The good news for digital photographers is that the latitude of a camera's image sensor tends to be marginally broader than most conventional negative films (and significantly so compared with reversal – slide – films). This means it is better placed to accurately record a broader range of brightness levels without extreme bright areas becoming washed out or the shadows becoming a featureless murk.

So how can you best visualize and interpret the brightness levels in the scene? A good way is to take a look at the Zone System, a powerful tool in many photographers' arsenals and one especially suited to landscape photography where getting the right brightness range is more critical.

UNDERSTANDING THE ZONE SYSTEM

Pioneered by, though not invented by, American landscape photographer and icon Ansel Adams, the Zone System is a specialized (and effective) way to get the best from a high-contrast scene. It's also a great way to visualize the brightness levels in a scene. In the system mid-grey – that which corresponds to the reflectance of the 18 per cent grey card (see page 43) – is assigned as Zone 5. Four zones represent darker tones in equal increments from Zone 1, pure black. Similarly, for brighter tones, Zone 9 describes bright white.

A digital camera sensor can accurately record across more than seven zones, so by analysing the brightest and darkest parts of the scene a median exposure setting can be used to gain maximum advantage of the latitude (sometimes called the subject brightness range) of the sensor. This will ensure that only extremely bright, or dark, parts of the scene will fall outside the sensor's range.

You can think of this as akin to setting the depth of field on lenses. In that case, you can determine the nearest point you want in sharp focus, and the furthest. You then focus the camera on a point (not necessarily halfway) between the two. You will then be assured that the lens will record the full distance range specified in sharp focus.

This is very much a basic – although very effective – précis of the Zone System, but it is sufficient for use as the basis of exposure setting.

NORMAL BRIGHTNESS RANGE
In this image, the brightness range between the brightest and darkest areas is around 6 stops. Calculating an exposure that is midway between the bright and dark areas will result in perfect exposure.

1. Brightest metered area (Zone 3)
2. Darkest metered area (Zone 8)
3. Mid brightness area (Zone 5)
4. Deep shadow – ignored

USING A BASIC ZONE SYSTEM

In order to make a good judgment of the exposure, it is important to recognize the following in a scene:

- the different brightness ranges
- whether the brightness range is likely to fall within the range of the sensor
- which area of the scene to take a definitive meter reading from.

The best way to do this? Choose a scene and take selected metering readings. Though you can do this in your head, for the first few attempts it's useful to note down the readings you take.

- Begin by selecting the lightest point in the image that you'd like to record accurately. This is not necessarily the very brightest point. In particular ignore the brightest reflections. Take a meter reading of this point.
- Select the darkest area that you need to have detail recorded in. Again, this is not necessarily the darkest, deepest shadow nor a black area.
- Calculate the difference in EV or stops between the lightest and darkest regions.
- If that difference amounts to around (you can be suitably imprecise here) 6 stops, you should have no difficulty in accommodating the brightness range. Take a shot at the intermediate EV (it can be useful in assessing the scene and training your eye to find an area that shares the same brightness level). Examine the image on your computer screen and in print. You should see that there is detail throughout the range.

WIDER BRIGHTNESS RANGE

The brightness range in this scene is approximately 9 stops between the brightest highlights and the darkest shadows. Although capturing detail throughout is beyond the range of the image sensor, careful assessment of the exposure will ensure that as little detail as possible is lost to blown highlights or shadows.

The lightest and darkest parts of the image are indicated by 1 and 2 respectively. These correspond (approximately) to Zones 1 to 9. If you meter off an area of Zone 5 you are likely to lose detail in both the brightest and darkest parts of the image. A more satisfactory result might be to meter off an area of brighter than average tone, equivalent to Zone 4. Then you would capture all the shadow detail (albeit at the expense of the highlights of Zones 8 and 9). Or if the highlights were important (as they might be were you shooting waterfalls or wedding dresses) you would meter off a brighter area corresponding to Zone 6 and lose detail in Zones 1 and 2.

1. Brightest metered area (Zone 3)
2. Darkest metered area (Zone 8)

HIGH-CONTRAST SCENES

When the contrast in a scene is high you often need to make a snap decision: expose for the highlights, the shadows, or an intermediate tone? That decision needs to be based on a determination of the critical element. Exposing a scene like this for the highlights doesn't give a satisfactory result (A): the brighter areas are better exposed but you have condemned too much of the shadow areas to featureless darkness.

Metering off an intermediate tone (the darker side of the stone) gives a more balanced result (B). It is possible to see more detail in the shadow areas to give a more satisfactory result. The exposure difference? A mere 1.5 EV. This shows how changes in exposure can result in a distinct difference in certain parts of an image and (in this case) prevent parts of the image becoming muddied. There is no doubt this is a fine balancing act. As your exposure skills develop and your visual acuity is sharpened, you will be able to judge those parts of a scene likely to become problematic when composing your shot. Such subtle variations make the case for exposure bracketing.

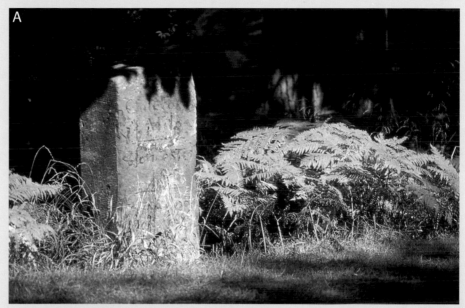

METERING FOR THE HIGHLIGHTS

METERING FOR A MID-TONE

WIDER BRIGHTNESS RANGES

Of course, the obvious question to ask now is what happens when the brightness range is greater? This is when you need to apply your photographic skill and judgment. To get a feel for what comprises a wide brightness range, repeat the process, this time choosing a scene with greater brightness ranges. A landscape lit by bright sunlight at midday is a good starting point. Or, perhaps, a beach scene or snowscape.

You'll probably find in such circumstances that you'll have brightness ranges of 9 stops or more. Which areas can you sacrifice, without compromising the integrity of the image? That will always depend on the subject. For the beach scene for example, the exposure would need to be correct for any subjects on the beach. This might mean that the sand will become over-bright, or detail may be lost in the sky.

For a landscape you may want detail in the shadow areas of the scene and again might want this at the expense of the sky. You might, subsequently, use techniques such as graduated filters (see page 72) to reduce the brightness range to within recordable limits.

An alternate method for those extra-special shots (on account of the extra work required in producing them) is to use high dynamic range techniques – digitally combining images with different median exposures to extend the range of brightnesses that can be accommodated in a single shot. Shooting these images is covered on pages 74–75 and the digital techniques involved are discussed on pages 108–111.

With an extended brightness range there is a certain inevitability that, when exposing for the important mid-tones, you will lose details in the highlights and shadow areas. You could have what the pros call blown highlights or muddy shadows. Over the page I'll explain exactly what I mean by these terms.

CHURCH PEWS
Lit only by sunlight diffused through mediaeval tracery, these church pews demanded careful exposure assessment. The photographer spot-metered from a bright sunlit area and then reduced the exposure by 1 EV. This kept the woodwork bright but intensified the rich honey colour. Reducing the exposure would have increased the saturation further, but at the cost of relegating the surrounding stonework to deep shadow tone.

FILM IMAGE

SENSOR IMAGE

DIGITAL SENSOR VS FILM

The wider exposure latitude of a digital sensor compared to film gives you more freedom (or more of a safety net) when assessing the tone in an image to expose for. For both these shots, the wall of the building was used as the metering point. The film image (Fuji Velvia, ISO 100) loses detail in the shadows and the cloud to the top left is showing burned-out highlights. In contrast, the sensor image contains detail in the shadows and in the cloud. This gives the photographer more opportunity when manipulating the image. These images are, intriguingly, the exterior of the oriel window at Lacock Abbey, featured in Fox Talbot's seminal image.

BLOWN HIGHLIGHTS AND MUDDY SHADOWS

Photographers often talk about blown highlights and deep shadows. What exactly is meant by these terms? And does it really matter, now that it is possible to remedy any image defect in the digital darkroom?

To answer the second question first, yes it does. Image-manipulation software and the techniques it permits can't put into a scene information and detail that was not there originally. You can see this most clearly if you examine image sharpening. Sharpening filters in Photoshop, for example, allow you to sharpen an image, but that does not actually produce an image equivalent to one shot with critical sharpness. Though perceived sharpness may have increased, it does not (and cannot) add back into the image detail that was not recorded in the first place.

So it is with highlights and shadows. Consider first the highlights. If a scene has a high brightness range, you might successfully expose for the main parts of the image. Those parts of the image that are lighter will be recorded as such but those parts of the image that are so much brighter that they fall outside the possible recording range of the sensor will not. Instead, the sensor will realize that above a certain brightness it cannot record further gradations: these areas, the highlights, will be recorded as the brightest possible white but no image data will be recorded within them.

THE WHITE SHIRT

Here's an example of how highlight detail is so easily lost. This scene has been exposed for the subjects: two people standing in a sunlit alley. The subjects' white shirts are, on the whole, correctly exposed. However those parts directly lit by the sun have blown highlights. There's no discernible detail on them. How can you be sure? Knock the brightness (using the Brightness/Contrast control) down to zero and these areas, though dimmed, and despite the absurd settings used for the controls, are featureless. All other areas retain detail as they are darkened.

DEEP SHADOWS

Conversely, some parts of an image may be so dark that they fall at, or below the minimum threshold that the camera's sensor can record. We see this represented in our images by dark areas devoid of any detail. Even if we adjust the brightness control we will see no detail. No detail has been recorded here and any adjustments made digitally will only enhance the random digital noise in the image. In this particular shot (as is generally the case), detailing in the background shadow areas is largely irrelevant.

WHITE SHIRTS IN THE SUNLIGHT
Exposure is spot-on for this shot as a whole – except on the sunlit shirts, where there is no data recorded. A classic example of blown highlights.

BLOWN HIGHLIGHTS
If proof were needed, by cranking the brightness down to zero, the blown highlights are still completely white with no features.

EXPOSURE VALUES

How do exposure values equate to real-world lighting conditions? In the table on the right, exposure values are compared with a typical lighting scene of that intensity. The table below relates different aperture/shutter speed combinations with the corresponding exposure value.

EV	Typical lighting condition
−6	Night, skyglow and starlight only
−5	Night, no artificial lights, moonlight (moon up to four days old)
−4	Night, no artificial lights, moon up to half phase
−3	Night, no artificial lights, full moon
−2	Night, no artificial lights, full moon, reflective landscape (e.g. snow)
−1, 0	Dim ambient artificial light, dim street lighting in distance
1	Distant view of lighted skyline
2	Average value of lightning at 5 miles/8km (time exposure)
3	Average value of skyburst fireworks (time exposure); candlelit portraits
4	Floodlit buildings and cityscape
5	Room interiors lit only with artificial light; subjects illuminated by bonfires
6	Brightly lit interiors; funfairs at night
7	Stage shows, concerts, sporting venues at night; well-lit roads
8	Department stores' window displays, bright city-centre lighting (with advertising etc.), incandescent light sources
9	Landscapes with sun 3 degrees (6 diameters) below horizon; stage subjects illuminated by spotlights
10	Landscapes with sun up to 1 degree below horizon
11	Averaged sunsets; subjects in morning/evening open shade
12	Subjects in open, under heavy overcast skies
13	Subjects in open, under light continuous cloud
14	Subjects in open, under moderate haze
15	Subjects in open, under bright or hazy sun
16	Subjects under clear blue sky with sand or snow cover
17	Dazzling artificial lighting; spotlighting at close range, extremely bright

Exposure Values for different aperture/shutter speed combinations

Shutter speed (1/sec)	Aperture (f-stops)												
	1.0	1.4	2.0	2.8	4.0	5.6	8.0	11	16	22	32	45	64
1	0	1	2	3	4	5	6	7	8	9	10	11	12
2	1	2	3	4	5	6	7	8	9	10	11	12	13
4	2	3	4	5	6	7	8	9	10	11	12	13	14
8	3	4	5	6	7	8	9	10	11	12	13	14	15
15	4	5	6	7	8	9	10	11	12	13	14	15	16
30	5	6	7	8	9	10	11	12	13	14	15	16	17
60	6	7	8	9	10 A	11	12	13	14	15	16	17	18
125	7	8	9	10	11	12	13	14	15	16	17	18	19
250	8	9	10	11	12	13	14	15	16	17	18	19	20
500	9	10	11	12	13	14	15	16	17	18	19	20	21
1000	10	11	12	13	14	15	16	17	18	19	20	21	22
2000	11	12	13	14	15	16	17	18	19	20	21	22	23
4000	12	13	14	15	16	17	18	19	20	21	22	23	24

GRADUATED FILTERS

Techniques such as bracketing and the Zone System are fine for ensuring that you get spot-on exposure when the dynamic range of a scene is within sensible – from a lighting perspective – limits. But what if you have two regions in your scenes with contrasting brightness? A landscape and the sky, for example. How can you faithfully reproduce one without compromising the other? Once every landscape photographer's kit bag would boast the solution: a handful of graduated filters. Digital techniques have caused many of these to be cast aside, but that's something of a shame as they still have an important part to play.

Graduates – as they are often called – are transparent coloured filters whose colour fades to clear in the lower part of the filter. They are available in a wide range of colours (including neutral grey) and different densities, corresponding to 1 or 2 stops at the darkest part. Though they can be used for special effects, they are creatively used to even out the exposure in a shot where the sky, typically, would otherwise be too bright to be accurately recorded with the same exposure given to the landscape. Some photographers would point out that you could reduce the brightness of the sky with image-

manipulation software and, to a point, they would be right. Unfortunately, while it is possible to reduce the apparent exposure of the sky it is not always possible to retrieve all the image information in the sky area. Getting a more even exposure in the first place is always preferable.

METERING WITH GRADUATES

Attach a graduate to your camera and the metering system will automatically compensate. Automatic compensation for filters can be useful for solid colour filters and some other types – such as polarizers – but is not so for graduates.

BRIGHT CLOUDS
The warm colours in this sunset scene would have been perfectly complemented by the structured and textured clouds. However, with the bright sunlight it proved impossible to expose accurately for land and sky in a single conventional shot (A). I added a 2-stop graduated filter over the sky, and the clouds can now be seen in all their glory (B).

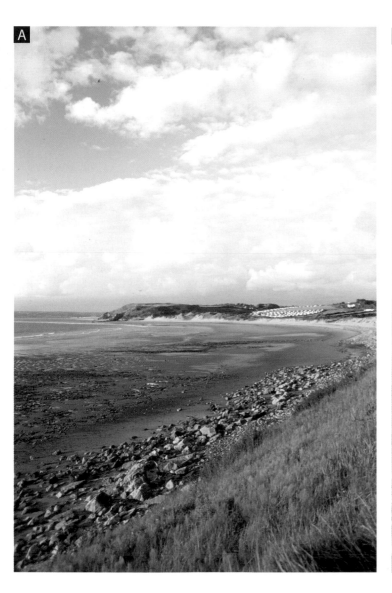

Technical tip

GRADUATES AND APERTURE
The transitional effect of the graduate on your scene will vary according to the aperture selected. At small apertures (f/16, f/22), the transition becomes sharper and more precisely defined. At wide apertures, the transition is far subtler. Because you may not want to compromise aperture for the graduate, manufacturers of professional-grade graduate filters offer different transitional widths for the filters.

The automatic compensation will tend to accommodate the lower brightness of the sky and increase the exposure over what it would otherwise be.

When using a graduate, it's important to meter without the filter in place and take the meter reading off that part of the scene that you want correctly exposed. You will then need to use the Exposure Lock (see page 39) to ensure that, when you slip the filter back into place, the exposure value does not change. Given that in landscape photography time is not always of the essence you might even prefer to work in full manual exposure mode, in which case exposure locking will not be required. Graduate filters are normally available offering, in the dark areas, a maximum attenuation of 1, 2 or 3 stops.

POSITIONING GRADUATES

Unlike solid colour filters, graduates need to be correctly positioned over the scene to give the correct effect. Placed centrally over the lens the graduation happens centrally across the frame. The graduation normally needs to correspond with the horizon line so, depending on your composition, you may need to slide the filter up or down or even rotate it slightly relative to the lens.

ENHANCED SUNSET
Normally a sunset shot would be exposed for the sky with the foreground landscape thrown into silhouette. Here, however, it was important to preserve the low-angle lighting on the foreground. Though well lit, these were much dimmer than the sky (A). Again, a graduate over the sky can help even the exposure and bring out the rich blue and yellow in the sky (B).

GRADUATE COLOURS
To preserve the colour of your landscape, grey – or neutral – graduates are the best bet. However, to make a clear sky more saturated or to enhance a stormcloud-laden sky, a blue graduate can help. Used with the coloured section to the bottom, green and emerald graduates can be used to increase saturation in grass and impart an azure tint to otherwise lacklustre seascapes.

CAPTURING A HIGH BRIGHTNESS RANGE

So, as we have seen, bracketing exposures will ensure that, given reasonably even illumination (or, rather, reflectivity) we end up with a shot that boasts accurate exposure. By refining selected images through mechanical intervention – adding a graduated filter – you can create a more even illumination in scenes with areas of disparate lighting. In this situation you might also want to hedge your bets with some bracketing, too.

THREE EXPOSURES
In the first image (A), the exposure (based on the amount of light entering the camera) is correct but the high contrast between land and sky means neither is optimally exposed. With a single stop overexposure (+1 EV), we reveal more of the shadow detail (B). A single stop underexposed (−1 EV), and more detail of the sky is revealed (C).

Graduated filters work very well where there is an obvious and linear division between the lighter and darker areas – as you find with the horizon, for example. But what if you have extremes of light and dark distributed throughout the image in a way that a single graduate filter (or even multiple graduate filters) cannot compensate for?

When you bracket your shots you'll end up with one – the underexposed image – that records a bright sky correctly. The overexposed image may properly represent parts of the foreground. Wouldn't it be great if you could combine elements of each of these two shots (or more if the brightness range is greater still and requires wider bracketing) into a single image? That's the premise of High Dynamic Range photography – or HDR photography for short. HDR techniques work by taking the best-exposed elements of two or more images to produce a composite that demonstrates an exposure that would not be possible from a single shot.

MORNING IN VENICE

The morning light on the Grand Canal in Venice makes for an evocative shot. The straight shot (A, opposite top) is a fair representation of the scene, but it hardly matches the memories. The sky is too bright and featureless and the cityscape is dominated by shadow.

With just a little experience of the vagaries of exposure you'd no doubt recognize the shortcomings when on location and bracket exposures, taking a shot at +1 stop and another at –1 stop. These give you a glimpse of the detail that is lurking in the shadows and also the fine texture in the sky, hidden in the straight shot.

Combining the best of all three shots into a single image (see pages 108–111) takes the

optimum exposed elements of each and produces a dramatic and imposing composite. This is something that bracketing alone can't achieve but makes an excellent case, when the lighting raises concern, for shooting a bracketed set.

see pages 108–111

Technical tip

BRIGHTNESS AND DYNAMIC RANGE
In digital photography, a high brightness range is more correctly described as a high dynamic range. You'll see the term 'dynamic range' used with regard to software and often used to describe the effectiveness of scanners.

COMPOSITE HDR IMAGE
Taking the most appropriate data from the digital images shot at +1, 0 and –1 EV compensation produces this impressive composite. It would be impossible to shoot in a single shot and is not really a faithful representation of the actual scene, but delivers a strong image. Courtesy HDR Soft.

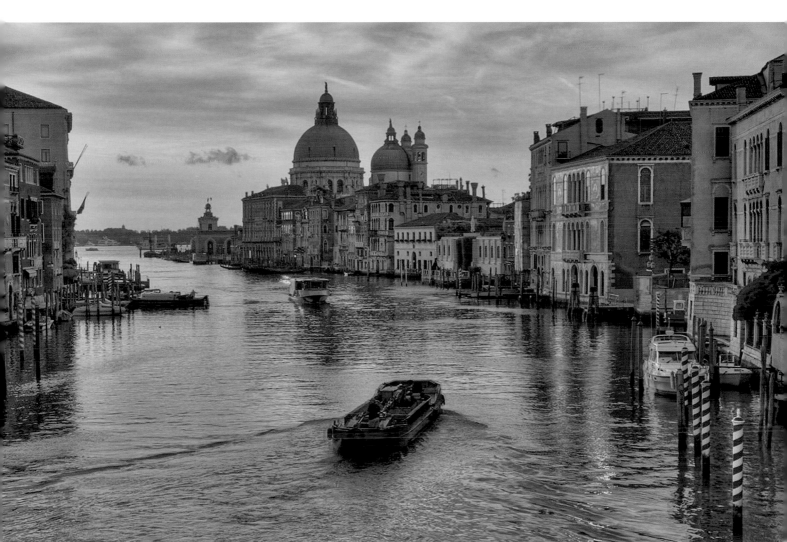

CLOSE-UP AND MACRO PHOTOGRAPHY

Shooting close-up and macro photos was traditionally a specialized field, requiring either specific macro lenses or extension tubes, designed to allow conventional lenses to focus on subjects close to their front element. For less demanding work you might use a close-up lens, attached to the camera lens in the manner of a filter.

With digital cameras, there is little difference between shooting subjects on a more regular scale and close-up. The metering systems in most cameras are adept at compensating for the short subject range, the lenses allow close-up work and the exposure systems will compensate automatically for any ancillary close-up equipment used.

Where you are likely to run into potential problems is in using cameras with non-TTL metering (see page 36) and in lighting your subjects. At short distances the camera lens and the meter could be looking at different areas.

Technical tip

THE DIGITAL MACRO ADVANTAGE
Not saddled with the need to conform to the size of standard film frames, digital cameras have something of an advantage when it comes to shooting close-up and macro. This advantage is greatest with digital compact cameras. By virtue of the sensor size and lens configuration you'll often find that digital compacts are adept at shooting close-up and even ultra-close-up images without any special equipment.

RING FLASH
Connected to the front of your lens, a ring flash provides even frontal illumination that can be balanced with ambient lighting if required.

CLOSE
For this shot the camera easily managed to focus, but the exposure would have been skewed due to the large dark background. Spot metering on the flower itself maintained an even colour and prevented overexposure.

Many digital cameras can shoot close-up without any special settings or equipment. For this shot of a flower, the camera's macro mode was selected and the camera positioned about 3in (7cm) from the petals. The exposure was calculated at fully auto +1 EV as the flower fills the frame.

EXPOSURE ERRORS

Exposure readings made by the non-TTL metering systems in compact cameras can be problematic, as these systems are designed to make exposure readings of objects on the lens axis in the middle and far distance. Close up, the subject will be below the line of sight of the meter and, depending on the lens configuration, masked by the lens.

How can you avoid misreadings? You can tilt the camera downwards so that the metering windows are facing the subject when taking an exposure reading, repositioning the camera afterwards. Or, often more successfully, you can take a reading from a portion of a grey card positioned nearby.

THE WORLD IN MINIATURE
This macro shot is successful not only because the subject is pin-sharp, but also because the exposure is spot-on, revealing every detail. Also note that through the use of a modest to wide aperture, the background has been rendered out of focus and provides a good backdrop to the subject.

LIGHTING CLOSE-UP AND MACRO SHOTS

Lighting problems in close-up and macro photography are not unique to digital cameras. If you think about the way camera and subject are positioned, with the camera lens (along with the bulk of the camera itself) very close to the front of the subject, there is a high probability of shading from the camera and little opportunity to light the subject from behind the camera.

Normal on-camera flash is of little use because the lens usually masks the subject, casting it into shadow. Your options are somewhat limited; you can produce your own modest scaled studio lighting configuration, or invest in a ring flash. Mounted on the filter thread of your lens, a ring flash provides even front illumination with all the control you'd expect (in terms of balancing the light levels with daylight, and exposure compensation) from a standard flashgun.

DEPTH OF FIELD

In the world of photographing the very small, depth of field becomes very shallow and focus critical. It's generally more successful focusing manually and increasing the illumination (whether natural or flash) to allow very small apertures. Work in aperture priority mode.

NIGHT AND LOW-LIGHT PHOTOGRAPHY

For many photographers, the sun going down is a signal to put the camera away. That's something of a shame because photography under low-lighting conditions can provide some spectacular photo opportunities. Of course these conditions will pose special exposure problems, but the results will be well worth the effort.

The good news is (and it may come as something of a surprise) that many exposure meters today are competent at determining the correct exposure even when lighting levels are really low. The skill comes in choosing where in an image you should point your meter and how the reading provided should be interpreted. The reading will need to be interpreted rather than just relied on because the exposure that the meter deems correct may not be the correct one for your shot. More so than in photography in brighter conditions, you'll need to modify any shots to get an optimum result.

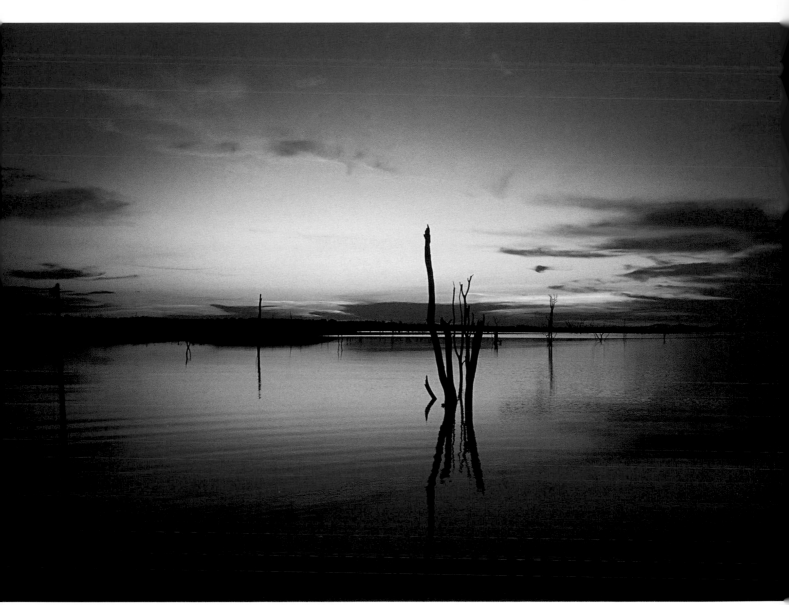

TWILIGHT
There's a surprising amount of colour in the twilight – though often your eyes don't have the colour sensitivity to recognize it. The camera reveals all but, as with sunsets, bracketing can deliver more saturated colours, particularly with modest underexposure.

THE RISK OF NOISE

Those who experimented with low-light photography in the days of film will have come across the problems of film grain. The greater the sensitivity of the film the larger the grain structure. Though the nature may be different, the change to digital imaging has not annulled this defect. Now you have traded grain for noise, a problem that has two main causes: long exposures and high sensitivity settings.

Long-exposure noise

As you attempt longer and longer exposures, random electronic fluctuations (which happen all the time) have the chance to accumulate and are interpreted as noise. Some cameras feature a crafty noise-reduction mode called dark frame analysis. By shooting a shot equivalent in duration to the intended shot but keeping the shutter closed, the camera can produce a map of the noise pattern likely to affect the main shot and compensate accordingly.

High-sensitivity noise

Setting the ISO to a high figure nominally gives you the creative freedom to use small apertures and/or shorter exposure times. The higher the ISO, however, the worse the signal-to-noise ratio. That is, the electronic noise levels are amplified in the cause of increased sensitivity to the point where they become significant and impinge on the image quality. At lower levels this electronic noise is at such a low level that it is easily masked by the image signal.

Pro tip

INSURANCE EXPOSURE SETTINGS FOR LOW LIGHT

If you're stuck for a baseline exposure setting when shooting at low light levels, take your first meter reading from the sky and reduce the exposure by 1 stop. This should give a good result from which – by reference to the LCD monitor on the camera – you can modify if necessary. This quick fix works well whether you're shooting a cityscape in the twilight, a sunset, or gloomy, stormy conditions. It will even work in the heart of a city in the dead of night where light reflection from polluted skies will give a good reading. It won't work, of course, if you're shooting at night and blessed with the darkest of skies.

SPACE CAMERA

Looking for all the world like a conventional digital SLR (which at heart it is, being based on the Canon EOS 20D), the EOS 20Da is a camera optimized for low-light work and astrophotography in particular. Though adept in duties as a regular digital SLR, it differs from its sibling in some subtle but important respects.

First, the camera features a low-pass filter in front of the image sensor designed to optimize the recording of diffuse reddish subjects such as nebulae. Second, and unlike just about every other digital SLR, the camera permits a live preview on the rear LCD monitor; this image can also be magnified so that precise focusing can be effected and monitored. This view can also be mirrored to a television monitor for even more critical image analysis.

DEEP SPACE EXPLORER
The EOS 20Da can shoot deep space objects requiring very extended exposures without many of the problems, such as noise, associated with normal digital SLRs.

IN THE DETAIL
The discreet 'a' suffix marks this camera out as one optimized for astrophotography.

DIGITAL NOISE
At high ISO settings digital noise increases. Here
the photographer has made the best of it by
enhancing it to give the appearance of film grain.

LIGHT SOURCES AT NIGHT

At the risk of stating the obvious, taking a
photograph requires light. This is also true when
shooting at night. In assessing a night or very
low-light scene you need to be aware of the light
sources in the prospective image in two respects.

First, you need to be conscious of the level
of the lighting. Many people shooting night
photographs for the first time get caught out
by the light levels. Shooting a floodlit building,
for example, they may set a long exposure
time and a wide aperture. The same might go
for a fairground ride. The result, in each case,
is overexposure. Remember, if you were to

shoot the building, or the ride, in daylight you
would probably record the light and lighting
successfully with a brief exposure. Hence, when
shooting at night, experiment with either long
shutter speeds at small apertures, or vice versa.

Second, at night the majority of light
sources will be artificial, and you might find they
significantly affect the white balance. Remember
the discussion on colour casts earlier. You will
need to determine whether you want the colour
casts to predominate or whether you want them
to be negated. Of course, if you choose to shoot
in RAW format you can delay your choice until
the image-manipulation stage.

GETTING THE BEST FROM NIGHT AND LOW-LIGHT PHOTOGRAPHY

For your expeditions into the world of low-light photography, the basic rules of exposure (as those for photography as a whole) still apply. It is just that they may need to be modified (or, perhaps, extended) for best results.

BRACKET EXTENSIVELY
Bracketing is useful in brighter light but is well nigh essential in low-light conditions. In fact, you will probably discover as you examine a group of bracketed shots that there is no such thing as a perfect exposure – several of your bracketed shots will look great. Each will have a different look and it will be up to you to judge which is best.

MANUALLY FOCUS YOUR CAMERA
Camera autofocus mechanisms flourish in bright and medium light levels. At low levels they can struggle to hit precise focus quickly. With SLR cameras this can be tiresome – as the camera hunts back and forth to find best focus – but not catastrophic. However, on cameras that don't offer SLR-type viewing you could easily shoot a number of shots without focus being established. Save time and avoid courting possible disaster by using manual focusing.

USE A GOOD SUPPORT OR TRIPOD
Unless the light levels are very high (in which case the scene would not strictly qualify as 'low light'), a solid mount for your camera is essential. This might typically be a tripod. However, if it is not viable to carry (or use) a tripod, you can improvise by propping the camera against any convenient support or invest in a robust pocket-type minipod.

USE HIGH DYNAMIC RANGE TECHNIQUES WHERE THERE IS A BROAD RANGE OF LIGHTING LEVELS
Light levels in the evening and at night will vary even more than during the day. A single scene might comprise bright light sources such as neon signage, street lighting and car headlights, the more discreet (perhaps moonlight and starlight) and everything in between. You can't hope to capture all these sources optimally in a single shot so bracket your exposures extensively and use HDR techniques (see page 74) to produce a final consolidated image.

TAKE ADVANTAGE OF THE FADING DAYLIGHT
Evening light can be better than night. If you have the choice of shooting at night or in the twilight, the latter often delivers the best results. There's more light around and this means there will be more in your photographs. In particular, a deep blue (or crimson, if you are particularly lucky) sky provides a far better backdrop to your scenes than a featureless and colourless black one would.

GET FAMILIAR WITH YOUR CAMERA'S CONTROLS
You may know how to make changes to your camera's controls when you can glance down at all the knobs and dials, but are you equally confident of doing so when, at night, you could well be working blind? It pays to get to know how to make changes to the camera's controls without looking. Get to know what the viewfinder indicators actually mean, too.

Technical tip

HOT PIXELS
On your camera's sensor hot pixels can happen anywhere, anytime. They look like bright stars but, as with general noise, are more obvious in darker areas and on longer – 30 seconds plus – exposures. They occur because some pixels can accumulate charge without light falling on them. And because charge is interpreted as incident light, that's what the camera's electronics see. Apart from avoiding long exposures, there's really no way to prevent them.

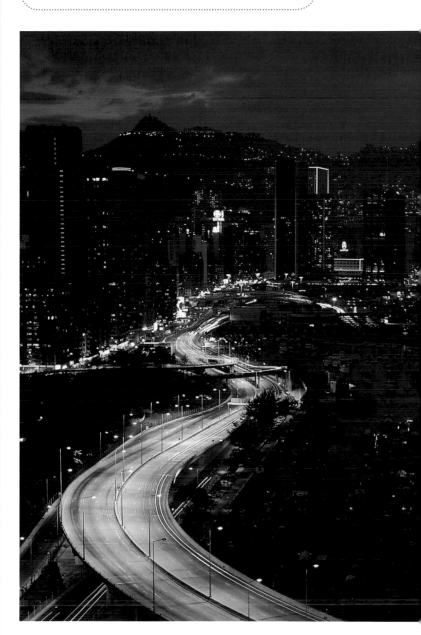

THE CITY AT NIGHT
As night falls over the city a whole new lighting scheme takes over from the sun. Shooting in the twilight produces the best images: here the sky-glow helps define the harbour and shows the distant lights on the hill in the background. As night rolls in and the sky is rendered black, both these areas would lose their impact.

CHAPTER 6:
FLASH EXPOSURE

Light – the one crucial element of all photography – can be fickle. No amount of planning and preparation and no amount of kit can prevent it conspiring to work against, rather than with, you for so much of the time. How many times has an errant cloud compromised those otherwise once-in-a-lifetime landscape shots? Or a stubborn, unshifting cloud marred a great portrait? It's not surprising then that many photographers turn their back on the vagaries of natural light and retire to a studio, where they have total control over the light. Flashlighting systems let you create lighting effects that it would be hard-pressed – if possible at all – to duplicate in nature.

Of course, flash and auxiliary lighting should not be confined to the studio – there will be plenty of occasions when a burst of bright light can do wonders outdoors too, augmenting the ambient sunlight. Through this chapter you will gain an understanding of how to get the perfect exposure with a flash system and also how you can combine ambient and flashlighting. You will also discover how special techniques – such as high- and low-key lighting – can be used, techniques that are particularly suited to flash and auxiliary lighting.

MULTIPLE FLASH PORTRAIT
Two flashes have been used to illuminate this portrait. A gentle, diffused flash illuminates the subject's face, and a stronger, direct flash (over the subject's right shoulder) lights her shoulder and provides additional definition for the hair.

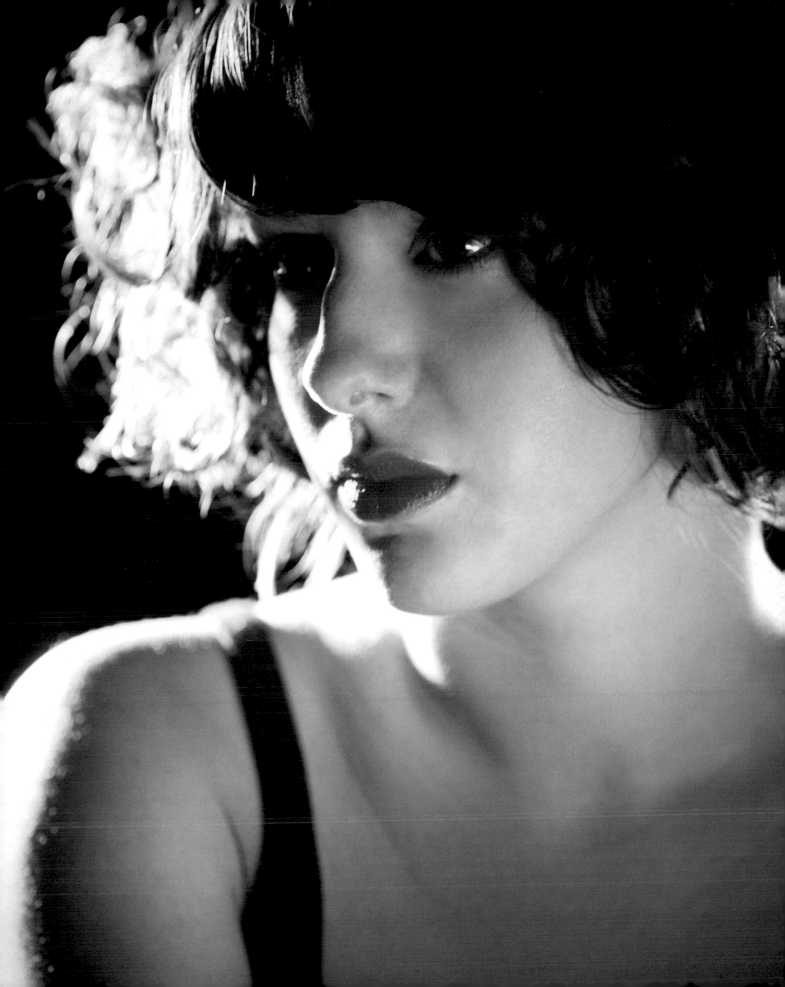

WORKING WITH FLASH

Flash duration is so brief – thousandths and ten thousandths of a second – that the shutter speed is immaterial: you vary the exposure by altering the aperture of the lens or the duration/strength of the flashlight.

When using flash you have total control. You may be using a single flash embedded in your camera or a complex configuration of multiple flashguns set up around a subject. Where flashlighting does differ significantly from ambient lighting is in its attenuation: the light from your flash units falls off in intensity with distance. Though this is true of all conventional light sources, this fall-off follows the inverse square law: double the distance between your subject and the flash and the light level will reduce by a factor of four; triple the distance and the light level will be one-ninth.

USING FLASH

There are, of course, many ways of using a flash unit. In some circumstances it will be the only viable source of light. A flash unit – or multiple units – will comprise the total lighting for a scene. You may also use flash to augment ambient light. Most commonly, this will be to provide some lighting to brighten shadows or give a better lighting balance in a shot, and is known as fill-in flash. Flash units today provide high levels of automation and also high levels of integration with the host camera. Rather like the advanced exposure systems in some cameras, sophisticated flashguns can deliver impressive results with just the minimum of intervention from the photographer.

FLASH METERING MODES

A flash unit will feature at least one mode of operation. As you might expect, the more sophisticated the unit, the more modes it will offer and the more comprehensive the control offered. All flash units will therefore offer at least one of the following modes; many offer all three.

Manual

In this, the most basic mode, the camera communicates with the flash system only to trigger the flash at the precise moment that the shutter is open. Unless otherwise configured, the flash will output its maximum level. Because of the essential independence of camera and flash, it is up to the photographer to set the controls (aperture, shutter speed and ISO) to match the flashlight levels that will be produced.

FILL-IN FLASH

Would you be inclined to use flash in the brightest sunlight? If you want to avoid the inevitable deep shadows that bright sunlight produces, especially if they fall on your subject, then the answer is yes. Fill-in flash involves balancing the output from the flash unit with that of the ambient lighting. Some camera/flash combinations can calculate the appropriate balancing flash automatically (usually when you select the 'fill flash' mode or equivalent), but you can set your system to deliver appropriate fill-in flash levels.

Set your camera to take a well-exposed shot of the scene, metering off the background or surroundings that are not in shadow. With your flash set to 'auto' or 'TTL' set this to 1 stop or 1 EV less. You can do this by setting an aperture 1 stop larger if in auto mode, or dialling in a flash exposure compensation of 1 EV in TTL mode. Take a look at the result and, if necessary, refine by adjusting the flash level in 1/3 EV increments. When you have a result you're happy with, make a note of the settings for future fill-in lighting tasks.

FLASH FILLED
Without flash, the bright sunlight has caused the subject to be in deep shadow (A). A burst of flash lights up the shadow areas and provides even exposure across the frame (B).

Automatic

In Automatic mode a sensor on the flashgun will monitor the flash intensity, as reflected from the subject. When the amount of light reflected reaches a pre-determined level (that from the ISO setting and aperture set on the camera and/or the flash), the flashlight is quenched.

The sensor on the flashgun is behind a small window on the main body of the unit. This ensures that if your flash has the ability to rotate, or you are able to tilt the head itself, the sensor is always facing the subject. Rather like centre-weighted metering in a camera, the sensor takes a general reading of the reflected light, biased towards an area approximately 30 degrees wide, ahead of the sensor.

TTL

Using a sensor in the flash unit can produce good results, but for the reasons just described it provides an approximate response and not one precisely matched to the lens in use. The best way to meter would be to use a sensor that measures light through the camera lens itself. It's the same principle as the main exposure metering system in the camera and, as such, will take account of the lens fitted and any accessory filters that might be placed over the lens. Communication between the camera and the flash unit will advise the latter of the settings made on the camera so that the flash can give the most appropriate light output.

The most comprehensive TTL features are generally offered by flash units that are matched to a specific camera model (or models); these are usually those produced by the camera manufacturer. The system will be able to identify not only the lens attached but also any special configurations, the focus distance and zoom ratio (where relevant) and adjust the flash accordingly.

Normally the flash will be directly attached to the camera (or connected via a short cable), but where the flash needs to be positioned some way from the camera, or where multiple flash units need to be used, wireless controllers attached to the camera can monitor and control the flash output.

The best mode to use? TTL, Auto and Manual, in that order. TTL will normally be the most effective in the widest range of situations. When you really want to do something at odds with the 'programmed norm' of the flash system then switch to Automatic. Make use of the LCD monitor to check your results.

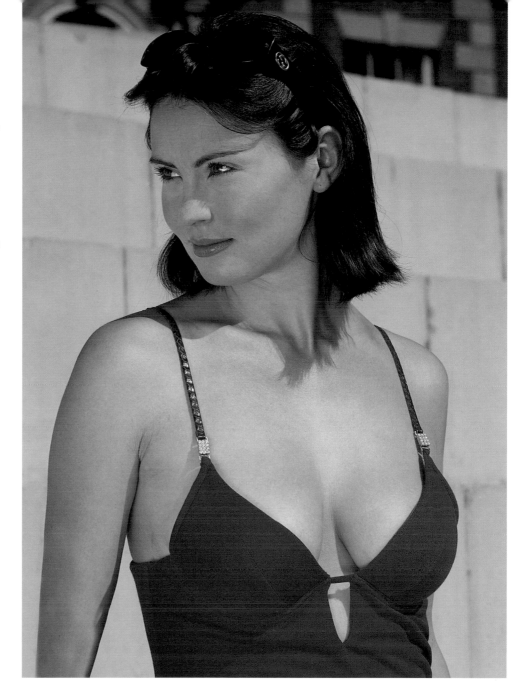

SUPPLEMENTARY FLASH
It may be a brightly lit day, perfect for vibrant colour, but the same sun that enlivens the colour will also cause harsh shadowing. A modest burst of supplementary flash will brighten shadows and give much more even lighting. The result appears completely natural yet is much more effective than that which would result without the supplementary lighting.

REFLECTORS
To achieve more balanced lighting effects, reflectors like these can be used to reflect light into shadow areas. They are particularly useful when using fill-in flash to brighten shadow areas that the flash may not otherwise reach.

USING FLASH WITH DIFFERENT CAMERA EXPOSURE MODES

What happens when you try to use flash with the exposure modes on your camera? Here's a brief run-down of how your camera will handle them. The assumption has been made here that the flash unit in use is one matched to the camera in use. The obvious caveat is that your camera may not support all these modes. Also, the efficacy of the relationship between flash and exposure modes can vary according to camera manufacturer and also from model to model. Treat the following as guidelines and experiment with your own camera and flash configuration in order to be sure of getting the best results.

Aperture priority

You set the aperture and the shutter speed is set accordingly. Assuming the subject is within the maximum range of the flash, it will be accurately exposed. You will need to determine the right balance between any ambient light and the flashlight, or use the LCD monitor as a cue.

Shutter priority

The flash output will be adjusted according to the aperture set by the camera after you have set the shutter speed. This mode might be useful if you want to control movement in the subject and, in particular, freeze high-speed motion by using the brief output of the flash.

Full auto

The flash will fire automatically when the light levels are determined (by the camera) to warrant it. It will do so whether or not you wish it. Often the results are unbalanced – with the subject correctly exposed to the detriment of the background.

Manual

If the flash is still set to Automatic or TTL it will provide the correct amount of flash to illuminate the scene; overexposure may occur if you have configured the manual controls with too wide an aperture or too long an exposure time for the ambient lighting. If you have set the flash unit to manual too, you will need to configure the output according to the subject distance and the settings made on the camera.

Program

Program modes vary but usually you will be assured of a good balance between flash light and ambient light under most average conditions.

DETERMINING A MANUAL FLASH LEVEL

How do you determine the amount of light produced from a flashgun in order to correctly configure the camera? The easiest way is to use a flash meter. This is a specialized exposure meter optimized to measure the brief transient flashlight (flash metering is also provided as a feature of some standard flash meters).

Without a flash meter you can use the tried-and-tested method of calculating the aperture required using the guide number – GN – of the flashgun. Every flashgun will have a guide number that is proportional to the output. Then, when the camera is set to ISO 100:

**GN = distance (metres) x aperture,
or aperture = GN/distance**

The instruction book for your flash will often do some of the calculation work for you and provide selected aperture figures. The guide number, it should be remembered, applies to the maximum output of the flashgun.

When the flash is used at a lower output (and still used to directly illuminate a subject), you can still perform the same calculations. If the light output is halved then the exposure time needs to be doubled.

Should you use the flash in bounce mode, it really requires that you use a flash meter for accurate results: the vagaries of the surface used to reflect and the distance to both the subject and the reflecting surface can affect the results markedly.

Technical tip

FLASH METERING IS REFLECTIVE METERING

Whether using Automatic or TTL modes, the metering method used with flash photography is reflective (see page 34). It is important, therefore, to be familiar with the way reflective metering works and also how the tonality of the subject has a bearing on the readings.

A SIMPLE STUDIO LIGHTING SYSTEM

Armed with a couple of inexpensive studio lights, or flashguns that are compatible with your camera, you can experiment with different light positions and intensities and observe the results directly on the camera's LCD monitor. The aim is to create images that capture the best of your subjects and avoid harsh, shadowless lighting. You can also experiment, as here, with different backgrounds.

STUDIO SET-UP
This modest studio set-up uses flash units that incorporate modelling lights – conventional lighting that allows the photographer to position the lighting units to get the best effect.

BRIGHT VASE
For this photograph, flash units above and to each side of the subject were used. The photographer used a flash meter to take readings from a grey card to obtain the best exposure.

DARK VASE
For this shot, which uses the same subject matter, the photographer substituted a dark background (and base) and used a single light from above and to the left of the subject. It was crucial here to meter off a grey card to get the dark, low-key effect (see page 90).

MACRO FLASH PHOTOGRAPHY

Shooting small-scale subjects should be no problem for your flash system – you'll generally find that TTL and Automatic should deliver good results. Problems arise, however, because when you are shooting small subjects close to the front element of your camera's lens there's a high risk that a conventionally mounted (that is, one using the camera's hotshoe) flash unit will be blocked by the barrel of the lens from properly and fully illuminating the subject.

You can overcome this problem by taking the flash unit off the camera and positioning it so as to provide the best lighting for the subject. To ensure that you preserve all the functionality of TTL and Automatic modes ensure that the camera and flash are connected with the correct cable and not just the standard trigger cable often provided.

Serious macro photographers may want to invest in macro flash units. Sporting either a ring flash head or multiple mini flash heads, both of which are attached to the lens' filter ring, these offer low-output flash burst better suited to macro work. The mounting of the units on the filter ring makes for better lighting and units often feature modelling lights – low-wattage lamps – that can be used for configuring the lighting prior to shooting.

The benefit of the ring flash system is that, being mounted on the camera lens, it is fully portable. If you need to make a quick, grabbed shot (as is so often the case when shooting small fauna), such a system is unrivalled.

There is no doubt that a ring flash system can produce impressive results; if it is not viable for you to invest in such a system then similar – but not identical – results can be achieved by using on-camera reflectors, taking care to match the size and positioning of those reflectors to the type and size of the lens attached.

MACRO FLASH

A unit such as this Nikon system allows multiple flash units to illuminate the subject and provides comprehensive lighting opportunities. The wireless control unit mounted on the camera's hotshoe will control these two flash units – along with any others that might be employed – and ensures full TTL control without wires.

FROG
The fruits of the labour. Macro flash enables subtle lighting of subjects on the smallest
of scales. The use of dedicated macro lighting allows successful blending of flashlight
and ambient light even with small subjects.

HIGH- AND LOW-KEY PORTRAITURE

High- and low-key are techniques that, while not limited to flash photography, are made simpler to achieve when we have absolute control over the lighting.

HIGH-KEY

The characteristics of a high-key portrait are that the lighter tones are permitted to predominate. Shadows are lightened through auxiliary lighting or judicious use of reflectors. In conventional photography we might describe this kind of lighting as flat or low-contrast, but on the opposite page it works to deliver a portrait in a romantic or feminine fashion.

It's important to note that high-key does differ from simple overexposure, although often overexposing a shot (compared to that suggested by the meter) does provide a good basis. The important stage is getting the lighting right. As already mentioned, you need to ensure there are no significant areas of shadow. Using a lighting set-up that includes substantial (or the option of substantial) fill-in flash would be ideal.

For the example shown opposite, the model was lit using a direct flash from the left, another flash that illuminated the background, overexposing it to white, and a third on-camera flash unit providing subtle fill-in flash.

LOW-KEY

Conversely, low-key portraits put the emphasis on darker tones. As you might expect, the results are overtly masculine portraits that often exude gritty strength. Unlike high-key portraits where there may be no elements darker than mid-tone, low-key portraits often feature small, brightly lit areas to counterpoint the shadows that would otherwise dominate.

The subject on the right was lit by a single flash, diffused to provide general lighting to his right-hand side. The diffuser ensured that the lighting was not too harsh. A modest amount of reflection from a wall to the subject's left meant that this side did not become too shadowed, and prevented the shot from being too high in contrast.

LOW-KEY PORTRAIT
Dark tones predominate in low-key portraiture.

CREATING HIGH-KEY IN PHOTOSHOP

Modest overexposure (around +1 EV) ensures that the subject is bright but still features a wide tonal range. Metering was made from the subject's skin.

This gives the basis for our image. It is brightly lit but not yet high-key. To make it so you will need to suppress the darker tones and accentuate the brighter ones. The best way to do this is using image-manipulation software. Traditionally, photographers would have worked on their images in the darkroom. Now you can achieve the same magic by using just two digital tools: Curves and Dodge.

The Curves tool (see page 104) allows you to vary the correspondence between input tones – those in your original image – and output tones – those that will comprise the final image. By adjusting the graph line – the curve – darker tones in the original image can be lightened. The Curves control also allows you to lock selected levels so that they can remain unaffected, ensuring you don't end up with a simple overexposed effect.

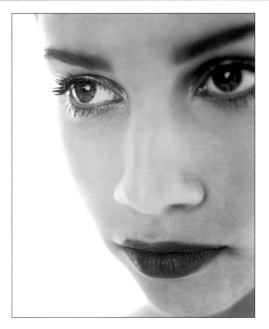

ORIGINAL PORTRAIT

CURVE
A modest uplift of the Curves graph will help you get the high-key effect. The adjustments will vary according to your original image. In this example, pulling the curve up at the bottom left lightens the darker areas; the flattening-off in the middle applies only modest lightening to the mid-tones; and the bulge at the top takes the lighter tones towards pure white.

To complete the portrait you'll need to dodge the image. With the Dodge tool you can brighten selected areas. Dodging needs to be undertaken subtly – as described on page 98. Gradually lighten selected parts of the image that are mid-tone or lighter. Slowly, your high-key portrait will emerge.

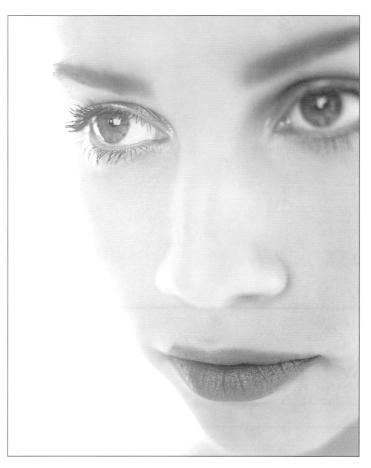

THE HIGH-KEY PORTRAIT
With discreet dark tones remaining, the rest of this image is bright, with the bright tones dominating. The result is compelling and very feminine.

CHAPTER 7:
USING DIGITAL MANIPULATION

Even the most proficient practitioner of exposure will know that it's not always possible to get things right in-camera. There are many reasons for this. You might simply not have the time to determine the precise exposure and have resorted to an auto-mode grabbed shot. The scene might have been one that it would have been impossible (perhaps because of the brightness range) to meter accurately. Or you might simply have got things wrong. These problems are nothing new. From the earliest days of photography, photographers were, in terms of exposure, prone to getting things a little wrong. They had the back-up of being able to then retire to their darkrooms – the photographic equivalent of the sorcerer's cave – and, through their skilled and practised manipulations, conceal any errors. Although the photographic darkroom is – for most of us – now of historical interest, the techniques it fostered, and much more besides, are now available to us in the form of digital image-manipulation software.

The fact that the digital darkroom is described as the spiritual (and actual) successor to the conventional darkroom is not without controversy. There are still a number of photographers who will eschew digital manipulations on the basis that it is 'cheating' and gives rise to photographs that owe little to the original. This leads to a contentious debate, but few could argue that the enhancements to the effective exposure of an image – although cheating – delivers anything more or less than that might be achieved using chemicals and light.

This chapter takes a closer look at how you can improve your images from an exposure point of view. It looks at how those traditional darkroom tools for evening up or enhancing contrast have come into the digital domain. It will also look at corrective tools that can overcome shortcomings in images that have been shot and how, by taking these a step further (and by some careful work when shooting) you can achieve some really powerful images.

EVENING LIGHT
Shooting scenes lit by the setting sun can be very rewarding, as the light can change by the second. However, contrast ranges can be excessive and getting a single exposure setting that works in-camera will be impossible. With some digital manipulation you can capture all the warmth and colour that would be lost in a 'straight' shot.

PROCESSING RAW FILES

In any discussion of digital manipulation techniques we need to begin at the very beginning, with the images newly downloaded from the camera. If those images have been stored in the camera's default JPEG or TIFF formats there is little more to say – you can move straight on to the editing stage. However, should you have opted for saving RAW images to your memory card, you'll need to use a RAW software application to import your images (these are often provided with your camera, though similar applications are offered online or in the equivalent module provided within your manipulation software itself). Because RAW images are 'raw' you can undertake some preliminary corrections during this import. The example shown here is representative of most and is that offered by Photoshop. Here's the recommended sequence of corrections.

CURVE CONTROL
Creative adjustment of the Curve can alter the exposure to precise degrees.

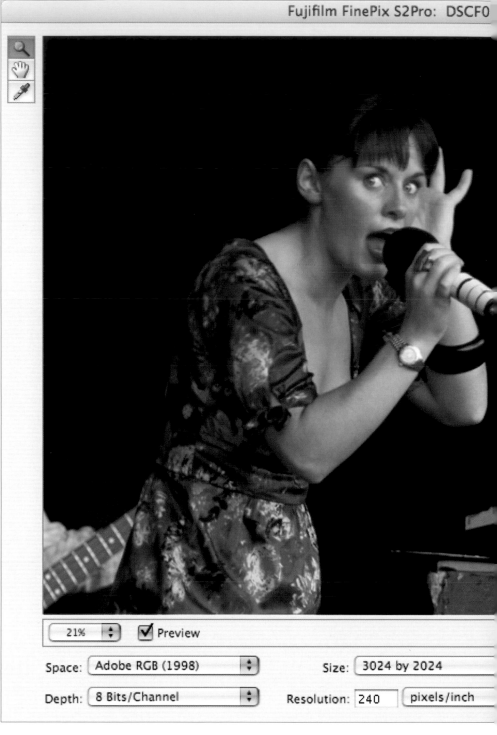

RAW WORKFLOW
When processing a RAW file, the sequence of corrections described here is the most fruitful.

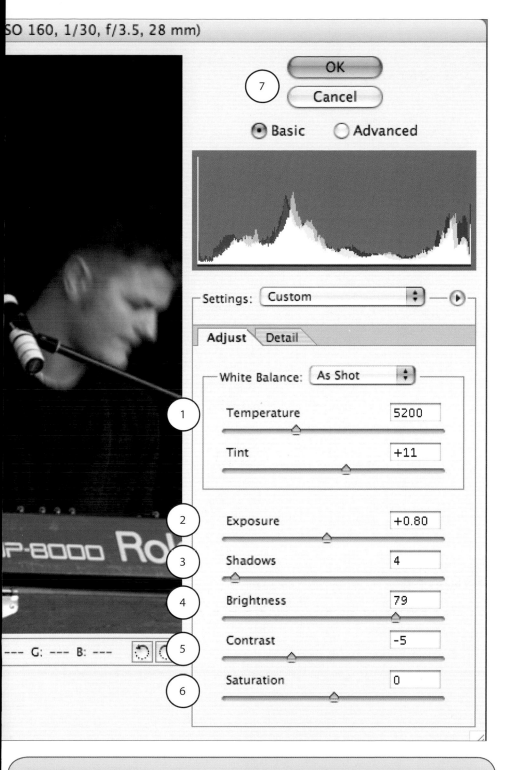

ISO 160, 1/30, f/3.5, 28 mm)

1. White Balance

Using RAW, no white balance corrections are applied in camera (see page 52) and so need to be applied now. There are some pre-configured settings (here accessed from the dropdown menu), but you can also set a colour temperature or a tint using the sliders.

2. Exposure

Correct your basic exposure here, if there is the need. A useful tip is to first click on the Auto button (which is found adjacent to the controls in some applications, including Photoshop Elements) to see what the expert systems incorporated in your software might suggest. If it looks good, use it; if not, make your own corrections.

3. Shadows

Use the shadow slider to make sure that your shadow areas are properly represented, with the darkest areas black (if appropriate).

4. Brightness

The brightness slider adjusts the mid-tones in the images. The more you slide it to the right the brighter the mid-tones will be rendered in your image. Move it further and you will end up with a high-key effect; to the left, a darker, moodier image.

5. Contrast

Perhaps more than any other control, the contrast slider can affect the mood of your image and needs to be carefully positioned to best represent the original scene. The more that you increase the contrast, the more likely it is that highlight or shadow detail will be lost. If you find you need to increase the contrast and this proves detrimental to the shadows or highlights, readjust the other controls until you reach a satisfactory result.

6. Saturation

Add or remove colour using this control. If you have skin tones in the image (or if you are adjusting portraits) these can be a great way of assessing the amount of saturation required. Too much and white skin becomes over-reddened, too little and it becomes anaemic.

7. Save

Save your corrected image. You're all set now for manipulating.

ADJUSTING CURVES

Some RAW file conversion software uses Curves adjustments in place of the Brightness control. If this is the case with your application (and at the risk of pre-empting what I will say later about Curves), you can duplicate the adjustments described here by dragging the midpoint of the curve upwards slightly to give the high-key effect and downwards – slightly – to darken the mid-tones.

You can use the Curves control to modify other components of the image by adjusting other parts of the Curves graph accordingly.

CORRECTING UNDEREXPOSED PHOTOS

The options offered by the RAW dialog offer the chance to make significant improvements to an image very rapidly, but rarely will you be successful in correcting some deficiencies, such as underexposure. And, of course, if you've used an image format other than RAW, you will not have had the opportunities in any case.

Before exploring some of the selective correction tools it will be useful to examine how to correct underexposure: in most images you'll need a tonally correct image to make a proper assessment of that image.

Many people, quite logically, assume that you can correct underexposure by using the Brightness/Contrast control. You can try this and sometimes have a modest amount of success. However, in place of these rather crude controls you can use Blend Modes, which can enact modifications that are not only subtler but can also be applied proportionally to the components of the scene. The methodology is best explored through an example, shown here.

It is worth noting at this point that image-manipulation applications such as Photoshop do provide more than one method of correcting underexposed photographs, and skilled photographic workers tend to be adept at each. No one method is right and another wrong; as your skills develop you will come to realize which method is best suited to a particular image.

WATCH OUT FOR...

... BLOWN HIGHLIGHTS
When you make corrections for general underexposure you can adversely affect any parts of the scene that are notionally correctly exposed in the original shot. Avoid this by masking (or selecting) these areas and excluding them from corrections to one or more layers.

... COLOUR SATURATION
Compositing layers in this way can lead to oversaturation of colours. Knock these back by using the Saturation slider in the Hue/Saturation control.

Pro tip

PARTIAL UNDEREXPOSURE
Where there is partial underexposure in an image you can use the Selection tools to select the underexposed region. Copy this to a new layer and apply the Blend Mode corrections just to that selection. Ensure that you set a feathered edge to the selection so that the corrections do not become too obvious.

STEP 1

An underexposed image such as this could have resulted from the photographer selecting the wrong manual settings, the meter reading incorrectly, or intended fill-in flash misfiring. Whatever the reason, the image is too dark to be acceptable.

UNDEREXPOSED IMAGE
This image is too dark, so exposure correction is necessary.

STEP 2

Begin by creating a new layer in the image, a duplicate of the Background layer (that is, the original image). The keyboard shortcut for this in Photoshop is Command J (Mac) or Control – J (Windows). In the Layers palette change the Blend Mode from Normal to Screen using the pull-down menu. The result is a lightened image – better than the original but still not perfect.

LIGHTENED IMAGE
Lighter (and brighter), but still not acceptable.

STEP 3

Repeat Step 2 as many times as necessary until you reach the stage where the exposure appears either correct, or slightly overexposed. Don't worry if you have to create two, three or even more additional layers – though you should normally eschew too many corrections, this is one situation where you can make an exception.

LIGHTER STILL
The image is getting closer to what you might consider a well-exposed one, but is still not quite right.

Technical tip

SHADOW/HIGHLIGHT CORRECTION
Where contrast is high it is not always possible to correct the underexposed elements without compromising brighter regions. In these situations consider using the Shadow/Highlight tool (see pages 106–107).

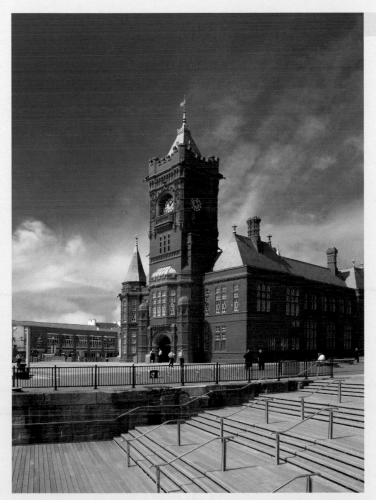

CORRECTED IMAGE
Just a little remedial work has rescued the shot.

STEP 4

To get the exposure set precisely, use the slider on the Layers palette, to the right of the Blend Mode menu, to reduce the Opacity of the top duplicated layer. When you are satisfied you can Flatten the image. Unlike some corrections where you might want to return later and modify settings and adjustments, in pure corrective manipulations you are unlikely to want to backtrack and underexpose the shot again.

This is a great way of fixing those underexposed shots. Often, however, you need to correct the exposure of parts of an image, selectively increasing and decreasing. This is where you need to explore a more traditional technique, albeit in digital form: dodging and burning (see page 98).

DARKROOM TOOLS

With the preliminaries sorted you can now get down to some more specific image manipulation. For this you take some obvious and rather literal cues from conventional darkroom tools: dodge and burn. Traditionally, dodging involves shading certain parts of the scene so that they receive less light from the enlarger and hence appear lighter in the final image. Burning involves allowing more light to get to areas of the scene and hence, appear darker when the image is processed.

Of course, like all darkroom techniques, getting the amount of dodge and burn right required a good level of skill and acuity. With no pun intended, you were working blind: although you could see on which part of the scenes you were enacting the modifications, the extent of those results were not obvious until the photo was processed. Nowadays you are fortunate in that you can see exactly what you are doing at all times, changes are performed live and, should you make an error, those changes can be reversed.

Digital Dodge and Burn tools are, strictly speaking, corrections to the scene lighting rather than exposure but in localized areas the tools provide an essential exposure correction. The key attributes of the tools might be described as:

- Enhancing and rendering more dramatic the highlights and shadows.
- Improving the exposure and making it appear more like the original scene.
- Bringing out detail that would otherwise be lost or go unnoticed.

THE DIGITAL DODGE AND BURN TOOLSET

The fact that you do have enhanced visibility of the tools and their operation only goes part of the way to making corrections easier. To exploit them to the full you need to explore how they work and also how they should be implemented.

The Dodge tool and the Burn tool share a common set of controls, as discussed below.

Brush

The way that you apply the correction is determined first by the Brush tool. You can set the brush to any size, softness or type (or any of these parameters as permitted by your image-manipulation application). It's generally best to select a very soft-edged brush so that the effect of any corrections you make is not too abrupt.

Range

You can selectively apply your corrections to different tonal ranges within the image. The options are Highlights, Mid-tones and Shadows.

DODGING AND BURNING
Flat contrast and technically correct exposure doesn't necessarily deliver an image that is perceived as visually powerful. Careful use of the Dodge and Burn tools will deliver an image where the exposure is more effective for the whole scene.

DODGING
The bronze miner is a powerful sculpture but deeply shaded. The contrast between this and the bright sky is too great for a well-composed image. Using the Dodge tool to lighten the mid-tones of the sculpture and also to lift the shadows you can get a stronger image with better colouration and a more three-dimensional look.

BURNING
You can add additional emphasis by darkening some of the shadows on the miner's face and also carefully burning-in parts of the sky to add to the drama. A low exposure setting was used to make the enhancements subtle and natural-looking.

You will find this useful when trying to make corrections to fine areas of an image. You can, for example, select Highlights when whitening a model's teeth. Then, should your brush stray on to the lips of the subject, the tool will have little visible effect (assuming, of course, that those lips are mid-toned or darker) on those areas. It's wrong to say that when set to, say, Highlights, the tool will have absolutely no effect on the mid-tones or shadows – there will be a very minimal modification of these areas too, but this will be so small as to be irrelevant. Normally you would use the Highlights setting most often when using the Dodge tool and the Shadows setting for the Burn tool.

Exposure

Subtlety is the key to getting good results when dodging and burning. Used at full strength they can be very harsh and obvious, so it's usual to adjust the strength of the tool using the Exposure control. Often you'll be using it at 10 per cent or even less, to get the most gradual of effects, building up density (or lightness) as steadily as possible to ensure authenticity.

Airbrush

This is not used in all applications, but where available the Airbrush button allows you to get even gentler results in the manner of using an airbrush. Using the Airbrush is probably more akin to the effect of traditional darkroom dodge and burn techniques.

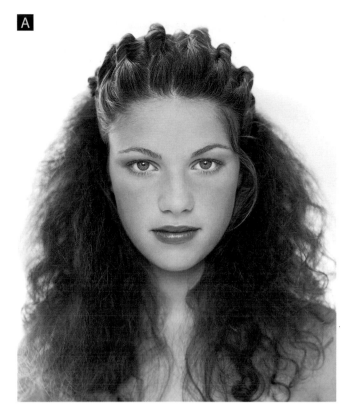

A

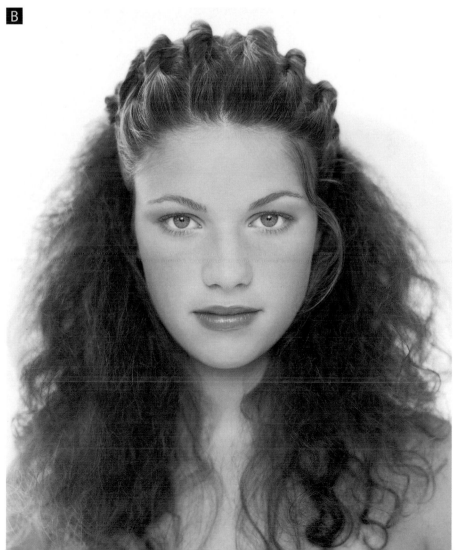

B

PORTRAIT
Dodge and Burn tools can be selectively employed to deliver results closer to those of the photographer's original intention, giving the visually correct exposure for each part of the scene, in this case the subject's face. The original image (A) has been manipulated with Dodge and Burn tools to produce a much less harsh, and obviously more flattering result (B).

USING THE DODGE AND BURN TOOLS

Although they are seen as corrective tools – and specifically with regards to improving exposure – the Dodge and Burn tools require a degree of artistic skill in their application. The effect is very much akin to applying paint when trying to enhance the shading in painted artworks. When using these tools, your aim should be to enhance the original scene, disclosing detail where appropriate and also delivering a more effective result overall. You will obtain the best results if you build up the effects slowly and gradually, using a soft brush and low Exposure. Step back from the image every now and then and check how your adjustments affect both the detail and the image as a whole.

The limitation with the Dodge and Burn tools is that they do need to be carefully applied to specific areas of an image. Getting the best results does need practice and, should you need to modify multiple areas in the image – to make good lacklustre exposure settings, for example – you will need to put in a lot of work. In fact, modifying tones throughout an image can be an onerous task and one better served by alternative tools: Levels and Curves. It is these tools that will be examined next.

In Photoshop (as with some other image-manipulation applications), the Dodge and Burn

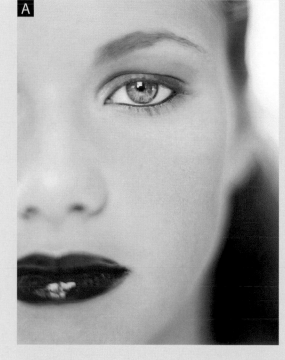

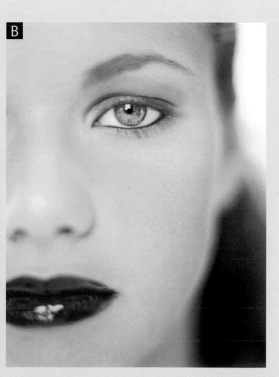

BURN COLOUR
The first image (A) has been burned and as a result the colours have become too intense. Using the Sponge tool set to Desaturate you can reduce the effect, creating a more natural-looking result (B).

CHANGING COLOUR WITH DODGE AND BURN TOOLS

Dodging and burning your image can have an adverse effect on the colour balance in those areas where adjustments are enacted. Burning, particularly, can intensify colour and this intensification is rarely satisfactory. The nature of digital images (particularly if stored as JPEGs or other compressed formats) is that there can be averaged blocks of colour. Although these are not normally visible they become all too obvious when that part of the image is burned-in. Similarly, random noise in the image and the associated colour can be intensified through burning.

You can use the Sponge tool (which in most Photoshop versions shares a menu location with Dodge and Burn) to desaturate the colour.

tool has a third option, the Sponge tool. This does not affect the exposure per se but rather is used to modify the colour saturation locally, in the same manner as the Dodge and Burn tools.

So why is it grouped with these tools? Essentially because when you modify the exposure in an image there is a high probability that, at least in some parts of the image, you will adversely affect the colour saturation. This is particularly true of images stored in JPEG format, where burning can enhance (in a negative sense) the colour in digital artefacts that arise as a result of compression.

Conversely, dodging an area can result in the colour becoming desaturated. This may not be an issue in terms of the local colouration in the area being dodged, but when viewed alongside areas of similar tonality that have not been dodged the results can be glaringly obvious.

The Sponge tool has the same controls as its stablemates, allowing you to choose a brush size and shape and also to set an amount of saturation and desaturation. Similarly the advice given for dodging and burning – to set a low amount of correction and build up the effect slowly – also applies here.

The example shown below demonstrates how the careful use of the Sponge tool can compensate for the oversaturation resulting from burning in parts of an image.

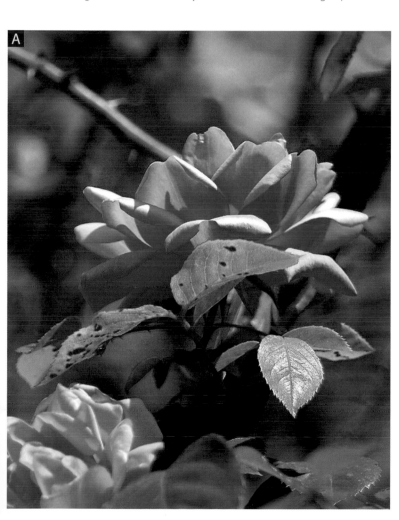

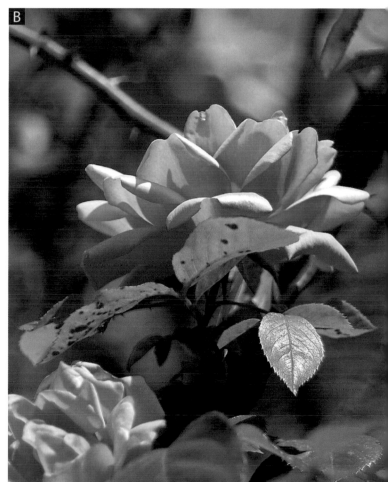

OVERSATURATION
Necessary but heavy use of the Burn tool to reduce the overexposure on this rose has been successful (A), but has resulted in the colour of the bloom and the nearby leaves (which were also burned-in) becoming rather lurid and unnatural, particularly when compared with the neighbouring regions. Gentle use of the Sponge tool (set to Desaturate) has knocked back the colour to a level similar to the nearby blooms and leaves (B). The 'glow' effect inadvertently introduced has gone and the result is much more natural, although still very colourful.

CORRECTING EXPOSURE USING LEVELS

Unlike the selective Dodge and Burn tool, the Levels tool provides a simple way to correct common exposure problems affecting images as a whole. It is particularly effective at correcting parts of a scene that might be underexposed and lifting otherwise dark and featureless shadow areas. When you shoot under high-contrast lighting such as bright, midday sun, it can produce hard shadows, which often compromises shots that are otherwise (technically) perfectly exposed.

Technical tip

SELECTIVE CORRECTION
As well as adjusting the Levels across the whole image, you can also make corrections to the Levels in selected parts of the image. First use a Selection tool to select the area requiring change. This may be spatially based (in which case you might use the Lasso) or colour based (use the Magic Wand, with the Contiguous box unchecked if you want to apply changes throughout the image). You can now apply corrections in the same manner as described in the step-by-step sequence.

STEP 1

Here's an image that illustrates a need for Levels adjustment. When you observe the histogram for the image there are some obvious indicators that the exposure and tonal distribution can be improved. First, there is an area to the right (the lightest tones) where there are no levels (ignore the spike at the extreme right, which is due to specular highlights). This is a little strange, as the day was bright and you would expect a better distribution. Second, that distribution is heavily skewed towards the darker tones, with the darkest clipped.

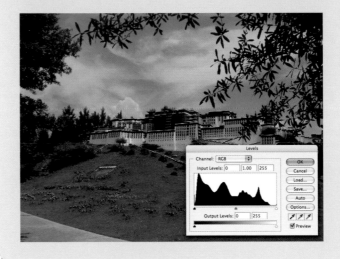

HIGH CONTRAST
Shot at midday in the tropics, this shot features more dark tones than you might expect.

STEP 2

How do you correct this to produce a more even tonal distribution? Take note of the small arrowheads beneath the Levels histogram. These three sliders represent, respectively, the black, mid-tones and white tones in the image. You can adjust the position of any of these by clicking and dragging. Wherever you move the white slider to will define the white point, and all tones of this brightness, or brighter, will be represented as white. Have a go at moving the slider and observing the effect on the image.

For the image being corrected here, move the white slider to the point where the final data on the histogram appears. The arrow now defines the white point, the brightest part of the image. You will now have a full tonal distribution. Careful adjustment of the mid-tones slider will also lighten the mid-tones without compromising the darkest tones.

WHITE POINT CORRECTION
Moving the white point slider to the last significant data point redefines the white point to the corresponding tones.

The result is an image in which the dark tones – those that had all become rather muddied and devoid of detail – now have both structure and colour. Look at the foliage, for example, which is now much brighter and more what you might expect of the incident lighting.

TONALLY CORRECTED IMAGE
Brighter and more lively (in colour terms), the corrected image now has an improved tonal distribution.

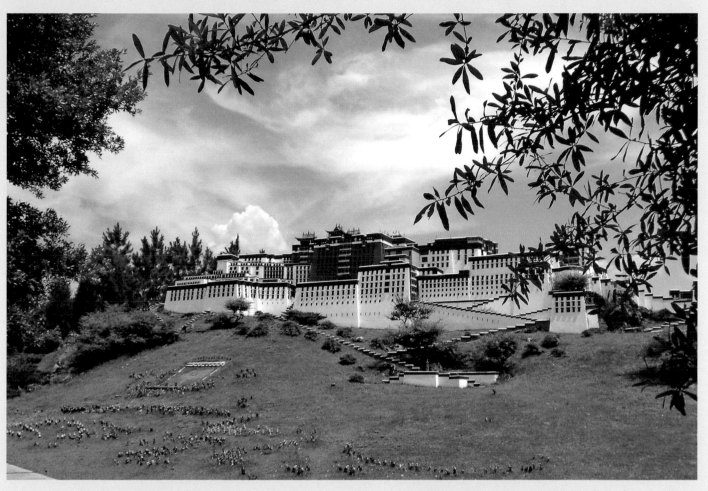

WHY NOT USE BRIGHTNESS/CONTRAST?

I mentioned with regard to basic correction that it is possible to use the Brightness/Contrast control to correct exposure errors, and those corrections would seem ideal for images such as this. This works to a point and can achieve a better tonal distribution, but the more experienced photographer will instantly recognize the attempted fix. In particular, you'll lose the true blacks in the image and produce a poor tonal distribution. The resulting truncation to the tones, as shown in this example, are as significant as those in the lighter tones we are attempting to correct – it is far better to use Levels for correct tonal distribution throughout the image.

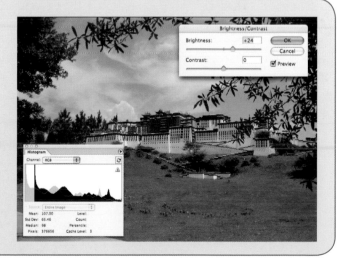

BRIGHTNESS/CONTRAST
Correcting images using this command compromises the darker tones, making them all lighter – there are no true blacks.

USING CURVES FOR EXPOSURE CONTROL

The Curves tool is, in principle, similar to the Levels tool in that it can selectively stretch or compress input tones. Unlike Levels (where you can only modify the highlight, shadow and midpoint tones) Curves allows far more control, using up to 16 user-defined tonal points.

COLOUR AND CURVES

Watch out for colour changes – in particular oversaturation – when adjusting Curves. Here the adjustment downwards of the intermediate mid-tones has resulted in overt colouration (especially in the orange tones) that looks very contrived.

OVERSATURATED COLOUR

Incorrect or overzealous adjustment can result in oversaturated colour. If the correction is correct for the exposure it may be necessary to use the Saturation control (set to Desaturate) to reduce the saturation in these areas.

ORIGINAL IMAGE
In the original image, opening the Curves dialog will show the default graph with its straight line.

BRIGHTENING MID-TONES
Create an anchor point midway along the curve and drag it upwards and you will brighten the mid-tones.

ADJUSTING CURVES

Selecting the Curves tool will open the Curves dialog with its key feature of a diagonally bisected graph. In its default configuration this graph represents the input tones along the x-axis and the directly corresponding output tones on the y-axis. The bottom left corner represents the deepest shadow area and, at the other end of the graph line, the top right the bright highlights.

Click on any point along the line and you can add an anchor point, a point where you can fix the position of the curve at a chosen value. You can drag this up or down to change the relationship between the input and output values. Raising the midpoint, for example, will lighten the mid-tones in the image. Because of the shape of the curve, adjacent tones are modified proportionally.

Should you not want all the tones to be affected in this way, you can add additional anchor points to limit the changes or even modify them in a different way.

As with the Levels command Curves does take a little experience on the part of the user for it to deliver its best. And, like tools such as Dodge and Burn, it is often the subtle adjustments that make for the best results. More significant modifications are likely to point to a problem with the original exposure and are inclined to reveal any digital artefacts or noise.

Technical tip

USING ADJUSTMENT LAYERS

An adjustment layer is an image layer to which corrections (such as Levels, Curves, Brightness/Contrast and even Hue/Saturation) can be applied. The net result is the same as applying the changes directly to the underlying layer or layers. However, applying changes using an adjustment layer means the original image is not touched, so remedial changes – if necessary – can easily be effected. You can even remove all changes by turning the layer off (by clicking the eye icon next to the layer in the Layers palette).

DARKENING MID-TONES
Conversely, drop the graph at the midpoints and the mid-tones will darken.

EXPOSURE CONTROL
By adding additional, or different, anchor points and adjusting accordingly, you have full control over the lightness of all regions in the image. This is important when you need to modify a component of the tonal range throughout the image (rather than selectively, as would be the case when using the Dodge and Burn tools). Lifting the mid-tones here has improved the general exposure, while a modest lift to the shadows (leftmost anchor point) has allowed more detail to be revealed in the man's hair.

SHADOW AND HIGHLIGHT MANAGEMENT

Correcting shadow and highlight detail and balance can be undertaken rather laboriously using the Dodge and Burn tools or more swiftly by adjusting the Levels or Curves. All these techniques are ultimately effective but do demand an element of expertise. What if you could apply a correction to an entire image – almost – at a single stroke? That's the premise of the Shadow/Highlight tool. The rationale of this tool is to lift those areas of the image that are in shadow – lacking in detail and colour – and suppress (if needed) the highlights to deliver an image that apparently manages to deliver correct exposure for more of the image.

Technical tip

THE BAD NEWS

Even this tool is not the universal solution for uneven exposure. If there is latent detail in your shadows – or highlights – Shadow/Highlight can find it. It is not an excuse for poor exposure; if your images are too overexposed rescue is impossible. If images – or parts of images – are too underexposed they can be hard to rescue and, worse, the corrective measures can accentuate digital artefacts and noise in the image.

STEP 1

This image is one that on moderately close examination shows not exposure errors but a lack of exposure latitude. Correctly exposed overall, there are murky shadows in the foliage at the lakeside and some parts – including the sky and the sponges hung from the rigging – are overexposed. Close examination of those sponges in particular suggests that the highlights have no detail left in them.

ORIGINAL IMAGE
Though technically correct, parts of this image are clearly overexposed, while murky shadows betray that others are underexposed.

STEP 2

Apply the Shadow/Highlight control in Photoshop by selecting Image > Adjustments > Shadow/Highlight. Doing so immediately applies the default settings to the image. This applies an intermediate amount of correction to the shadow details, brightening them so that you can see colour and texture that was previously concealed. It makes no obvious correction to the highlights.

SHADOW/HIGHLIGHT CORRECTION
The default correction makes obvious changes to the shadow areas.

You can fine-tune the amount of shadow correction using the slider. When happy, adjust the highlights. Moving the slider to the right reduces the brightness of those highlights, in this case making a dramatic difference to the sky (which is no longer washed-out) and, perhaps more impressively, revealing detail in those formerly overexposed sponges. More precise adjustments can be made using the extended controls (see panel).

CORRECTED IMAGE
By fine-tuning the settings you can improve the modifications and make them more realistic. Note the improved sky and the detailing on the bright sponges.

OVERCORRECTION
Be too heavy-handed with your application of the Shadow/Highlight controls and the results can be too extreme. The first image (A) suffers from some significant shadow areas and a rather washed-out sky, both of which can be enhanced by using the tool. However, if you were to use the sliders to their full extent (B), the shadows are virtually eliminated. This is not a natural condition and the manipulation is now too obvious.

THE EXTENDED SHADOW/ HIGHLIGHT CONTROLS

Click on the Show More Options button in the Shadow/Highlight dialog and you will see there are some further controls to experiment with.

Tonal Width: lets you widen or narrow the range of tones that will be adjusted when you apply the tool – for example to adjust only the darkest tones and leave the mid-tones unchanged.

Radius: defines how many pixels adjacent to that being adjusted are also affected. The greater the radius (in general) the smoother the result.

Colour Correction: determines how vivid the colours in corrected areas are.

Adjust the Mid-tone Contrast to finely adjust the image contrast in areas subject to adjustment.

GOING TO EXTREMES

The amount of control offered by this tool is significant so it is important that you don't over adjust. If, for the scene shown here, both the shadow and highlight adjusters are moved too far, the result is an overcompensated Image. The balance between shadow and highlight areas is now lost and the image colouration and tonality verges on the surreal. Quite clearly in this case, less is more.

COLOUR CORRECTION VIVID
Slide the Colour Correction slider to the right and the colours become more vivid, as seen here.

COLOUR CORRECTION NORMAL
Set to the normal default setting, the Colour Correction slider delivers conventional colour saturation.

EXPOSURE BLENDING FOR HIGH DYNAMIC RANGE

The Shadow/Highlight tool is often a simple and effective way of enhancing a shot and producing a result that can be more successfully printed. When the dynamic range in the shot is greater than what the sensor can record, you exceed the limit of what the command can accommodate however. When that is the case – that is, when a single exposure is insufficient – how would it be possible to accurately record the scene?

A clue to the answer to that question is in the term 'single exposure'. If a single exposure is unsatisfactory then we must consider an image – a final image – that comprises more than one original exposure. For that you need to consider high dynamic range (HDR) techniques, which we discussed from a photographic standpoint on page 74. First, though, let's look in a little more detail at what is meant by high dynamic range.

WHAT HIGH DYNAMIC RANGE ACTUALLY MEANS

The sensor in a digital camera has a limited ability to record a range of brightness values. You can alter which brightness levels the camera will record by varying the amount of light reaching the sensor. So, for example, with the shutter open wider and/or the exposure time increased, you can record detail in the shadow areas of a shot. Reduce the aperture and/or the exposure time and only the brighter highlights will be recorded. So, in effect, the sensor has recorded details throughout the range in the scene, but required two (or maybe more) shots to do so successfully. Neither shot on its own is sufficient.

Your eyes, on the other hand, are effective at elucidating detail in the brightest parts of a scene and the darkest shadow areas virtually simultaneously. Creating an HDR image by blending two or more conventionally shot images is one way to extend the range in an image and deliver a result that more closely matches that of your eyes. There are two techniques for producing HDR images.

Exposure blending

This process requires at least two (and normally three) images that between them fulfil the requirements of containing image data throughout the dynamic range of the scene.

Tone mapping

In this process, the tonal range of an image (comprising two or more original images) is compressed so that details in the highlights, shadows and all points in between are mapped to the range of the output medium (that is, the computer screen or printing paper, as appropriate).

In essence, then, HDR photographic techniques are about capturing the luminosity of a scene as it actually is, without clipping the pixels in dark areas or bleaching those in the brighter areas.

BRACKETED EXPOSURES
Although this scene does not overtly show extremes of exposure, there are areas that cannot be recorded accurately with a single shot. In each of the bracketed images it is possible to see those areas that are correctly exposed.

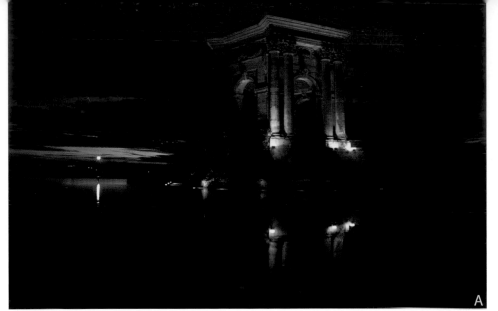

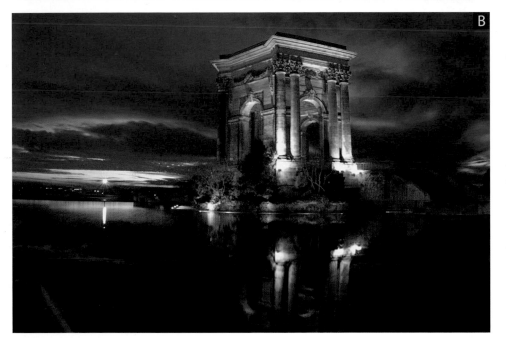

CONSOLIDATING HDR SHOTS

To consolidate two or more shots taken with different exposure values requires that you use specialized HDR software, available as plug-ins to conventional image-manipulation programs and as stand-alone applications. Whichever you choose, the consolidation process is identical and, thankfully, mostly automatic. The software requires that you first identify the images that will be used to produce the final HDR image. You will then be prompted to define some of the shooting conditions in order that the composite can be made more effective.

- Were the multiple shots made using a tripod? If not, the software will automatically align the shots to make sure that the key elements overlap precisely.
- Were there any transient objects in the shots? As you have taken multiple shots with a finite time between them, there is a risk that some objects – people, vehicles or even ripples on water – may have moved between the shots. Checking this box will ensure that there is no image ghosting.

The blending process can then be applied. The dialog box allows modification of the process as to where blending occurs and also the Radius (that is, the pixel distance) of where that blending should happen. These are, essentially, fine-tuning controls, and need only be adjusted if the automatically generated HDR image requires it.

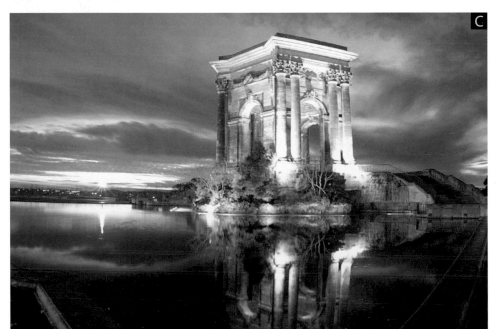

SOURCE IMAGES
These three images were shot with exposure compensations of –2 EV (A), 0 EV (B) and +2 EV (C) respectively compared with the metered exposure. It is obvious that there are areas in each that are well exposed and areas that are either over- or underexposed beyond the point where they can deliver useful image data.

THE BENEFITS OF HDR TECHNIQUES

- **Great pictures in adverse weather conditions:** HDR techniques let you extract tonal information from the dullest overcast sky and enhance the cloud structure no matter where.
- **Well-exposed panoramas:** Panoramic photography involves shooting up to 360 degrees around the horizon. The standard shots will inevitably result in uneven exposure and illumination. This can be corrected to deliver a uniformly lit panorama.
- **Noise reduction:** Especially at low light levels, electronic noise can compromise your images, particularly in areas of constant colour and tone.
- **Post-processing time savings:** There is nothing here that you couldn't do by using a conventional image-editing application – provided you are pretty skilled and that you are prepared to devote a considerable amount of time.
- **Better results:** The raison d'etre. It delivers results that are better than you could get with a 'straight' shot and better than you might achieve with some substantial manipulation. It's what, in the digital world, bracketed exposures were invented for.

FINE CONTROL
HDR software acknowledges that discrete shots need to be consolidated and allow for fine-tuning of the positions and also avoid moving objects appearing as ghosts.

HDR DIALOG
The HDR imaging dialog box (here from HDRsoft's Photomatix) offers fine-tuning control. Often only a modest correction here – if any at all – is required.

THE HDR IMAGE
The final image features detail in all elements of the scene. Compare this with that image shot at 0 EV compensation that should, notionally, be similar and the advantages of HDR techniques become obvious.

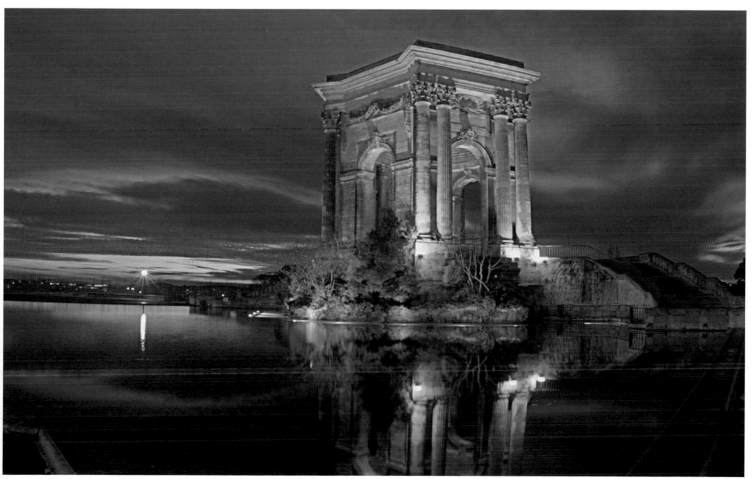

PICTURE ASSESSMENT AND MODIFICATION

You've now looked at the tools available in applications such as Photoshop that are of specific interest when making exposure changes. It is easy, though, to examine all of these in isolation and look only at the corrections that each can impart. When you come to correct or enhance an image you will generally need to use techniques that involve multiple tools. That process should be part of a general improvement regime that should include consideration of the colour balance and contrast along with the exposure itself.

So, when faced with an image, in what order should you attend to corrections? Here's a recommended programme. It's not the only one, but it's one that makes good sense. Best of all, it avoids making adjustments or corrections that might compromise the image if done in an alternate order.

- Sort your images – discard those second-rate and poor examples.
- Convert RAW files (assuming you've recorded in RAW format).
- Attend to compositional adjustments.
- Tidy up the image.
- Adjust the contrast.
- Perform local exposure adjustments.
- Adjust the colour.
- Sharpen the image (if relevant) prior to saving.

Let's expand this brief outline and look at how this workflow fits in with your attempts to deliver images with the best possible exposure.

SORTING IMAGES

You need to be sensible when sorting images. Though digital corrections allow you quite a latitude not all images can be rescued. Don't be afraid to discard those that are beyond sensible repair. Digital photography encourages you to shoot numerous alternates so there will be some redundant images.

CONVERTING RAW FILES

When (or if) you import your RAW images you have the opportunity to adjust the overall exposure of your images as part of the conversion of the 'raw' image data. Adjustments here tend to be global so you will need to make an adjustment that delivers apparent good exposure for the greatest part of the scene. Check that the changes you make don't leave you with large areas of the scene where the highlights are left featureless or shadows too dark. Select an optimum level so that you can extract the most information from these regions later.

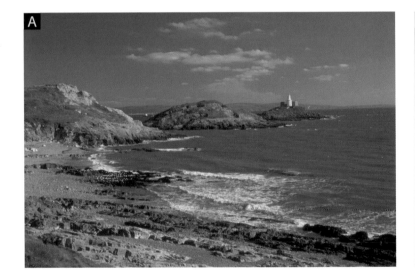

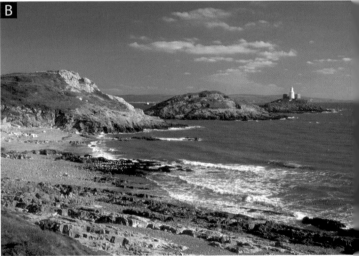

IMAGE WORKFLOW
Straight from the camera this image (A) has poor colour and lacks contrast. Unforgivably, it has also been shot at a slant. Adjusting the colour balance and increasing the overall contrast slightly gives a much more pleasing result (B). The opportunity has also been taken to straighten the image (which will inevitably involve a modest crop of the image). For the final image (C), selected areas have been dodged and burned to increase the local contrast and give the image greater depth. Care has been taken not to burn too intensively. This can cause oversaturation of the colour in those areas. A final sharpen (using a modest amount of the Unsharp Mask filter) completes the image.

COMPOSITIONAL ADJUSTMENTS AND TIDYING

At this stage you might want to crop the image to improve the composition or remove distractions from the edge of the frames. When tidying the image you can use the Clone/Rubber Stamp tool to remove distractions that are further into the frame. You might also be able to use the Clone tool to disguise areas of extreme exposure in the frame.

ADJUST THE CONTRAST

Use Auto Contrast if it gives satisfactory results, or Levels for more considered corrections. You can use the Eyedropper tool to neutralize colour casts if appropriate at this stage and reduce the amount of colour correction that you might need to use later. You might also want to use the Highlight/Shadow tool (see pages 106–107). This tool is often more successful at brightening shadow areas that tend not to be sufficiently lifted by the Auto Contrast tool.

PERFORM LOCAL EXPOSURE ADJUSTMENTS

For that read dodge and burn. This might be to refine the general exposure corrections of the Highlight/Shadow tool or to instigate new adjustments. This is the artistic bit and it pays to work gradually and avoid overemphasizing areas.

ADJUST THE COLOUR

Exposure and contrast adjustments can affect the colour. Neutralize such effects now either using the Sponge tool (set to Desaturate) to provide local adjustment or the saturation control of the Hue/Saturation tool for more general correction. If you have zoomed into parts of the image to make the corrections zoom out to assess the overall effect of your changes.

SHARPEN THE IMAGE

If your image needs a little sharpening to give it the look of critical sharpness, now – prior to saving and printing – is the time to do it. Don't sharpen at the outset or an intermediate stage because you will introduce artefacts that, while not problematic now, would be so earlier in the process. These artefacts tend to emphasize colour variation and would be exacerbated when contrast or exposure adjustments are applied.

When sharpening it pays to get to grips with the Unsharp Mask tool. Unlike the Sharpen and Sharpen More options (which are indiscriminate in their application), you can set the parameters of this tool to suit the content. In particular, you can set a threshold (which determines the amount of variation in tone) below which sharpening is not applied. This prevents sharpening being applied to (for example) areas of sky or skin tone where such sharpening would not be required or desirable.

Applying corrections to a number of images as part of a workflow is generally a step-by-step process. Over the page we look at an alternate method of improving your images – using workflow applications.

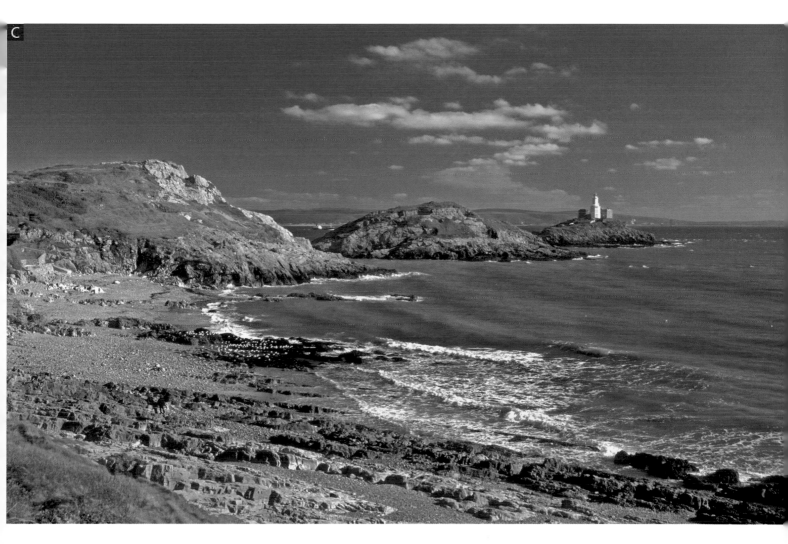

C

USING WORKFLOW APPLICATIONS

Workflow applications – such as Apple's Aperture and Adobe's Lightroom – are targeted at the professional and serious enthusiast. Unlike Photoshop and other conventional image-manipulation applications (which are essentially designed for working on individual images), workflow applications are designed to process multiple images as swiftly and consistently as possible. They also have a toolset that differs slightly – particularly in emphasis – from those traditional applications.

ADJUSTMENT TOOLS
Here (in Apple's Aperture) the adjustment tools are conveniently grouped together making adjustment simple.

STEP 1

Taking Aperture as an example, making corrections is simply a matter of using the sliders, in exactly the same way as you would do so in your image-editing application. Useful assistant tools include the Hot Area indicator. As you make your adjustments any areas that are overexposed (and would reproduce as featureless white in the final image) are indicated by solid colour (red in this case).

ORIGINAL IMAGE
Useful indicators (the red areas in this image) define those areas that are overexposed.

STEP 2

Move the exposure slider to the right and you'll see, as you might expect, that this area will grow as more and more of the image becomes overexposed.

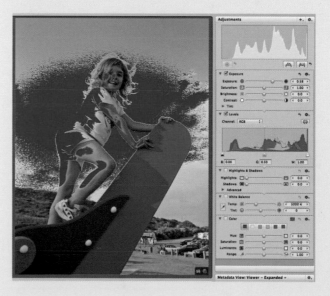

OVEREXPOSURE
Moving the exposure slider further to the right shows how more of the image would become overexposed in this situation.

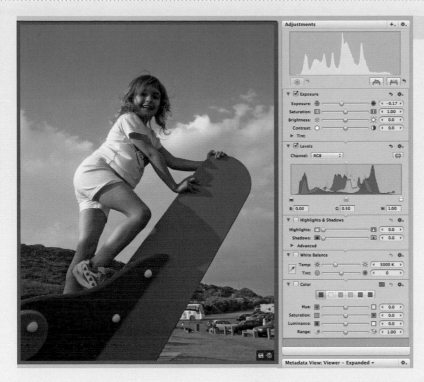

STEP 3

You can now nudge the exposure slider to the left until the last area of red disappears. You should also consider adjusting the saturation, brightness and contrast to ensure correct exposure.

You'll also see that you can make other adjustments including Shadow/Highlights (see page 106), white balance by colour temperature or tint (see page 95) and Hue/Saturation. You can iteratively adjust all these tools near simultaneously.

CORRECTED IMAGE
Moving the slider so that no overexposed areas remain corrects the exposure errors – although further corrections will probably also be necessary.

If you're familiar with any photo-editing application your first encounter with a workflow application can be a bit daunting. The layout is quite different and is geared towards the viewing and processing of a number of images simultaneously if required. While they have a core set of manipulative tools (such as Red-eye removal, Crop, Heal and Patch) the power is in the adjustment features, among which the exposure tools feature prominently. You'll find them, in Aperture, at the top of the Adjustments panel, or in the Quick Develop panel if you are using Lightroom. One of the more useful features is that the exposure adjustment tools, which in traditional image-editors require individual selection from submenus, are now all grouped together and you can make adjustments to several aspects simultaneously.

So, do workflow applications offer better exposure control? No. Do they let you work more effectively? Yes. Can you make corrections to a set of images quickly? Yes. And that's really the purpose of these – fast, reliable and repeatable corrections.

LIGHTROOM
This Adobe software provides a useful adjunct to Photoshop for processing and comparing large numbers of images.

CHAPTER 8:
INSTANT EXPERT

Through the sections of this book I hope you will have come to realize that getting the best exposure for your shots is more than simply setting the notionally correct aperture and shutter speed. You will probably have realized by now that exposure control is something that needs to address all aspects and elements of your photography – creative as well as mechanical.

Exposure mastery is something that will be accomplished in different ways for different genres of photography. This chapter examines each genre and distils all the exposure knowledge – and good practice – gained so far.

The nuances and subtleties of exposure can be overwhelming, especially if in the past you have relied on the automatic exposure system of your camera (or even luck). However, when laid out objectively they become more obvious and easy to assimilate.

For each photographic style this chapter will identify: what the aims and objectives should be, in exposure terms, when shooting; any issues or potential pitfalls that you need be mindful of; the best exposure modes including, where available, special programmed modes; the essential kit you need to pack to make the best of the respective opportunities and tips for getting the best results.

A MATTER OF BALANCE
Good exposure is a balancing act: what is considered best for one part of the image might be inappropriate for another part.

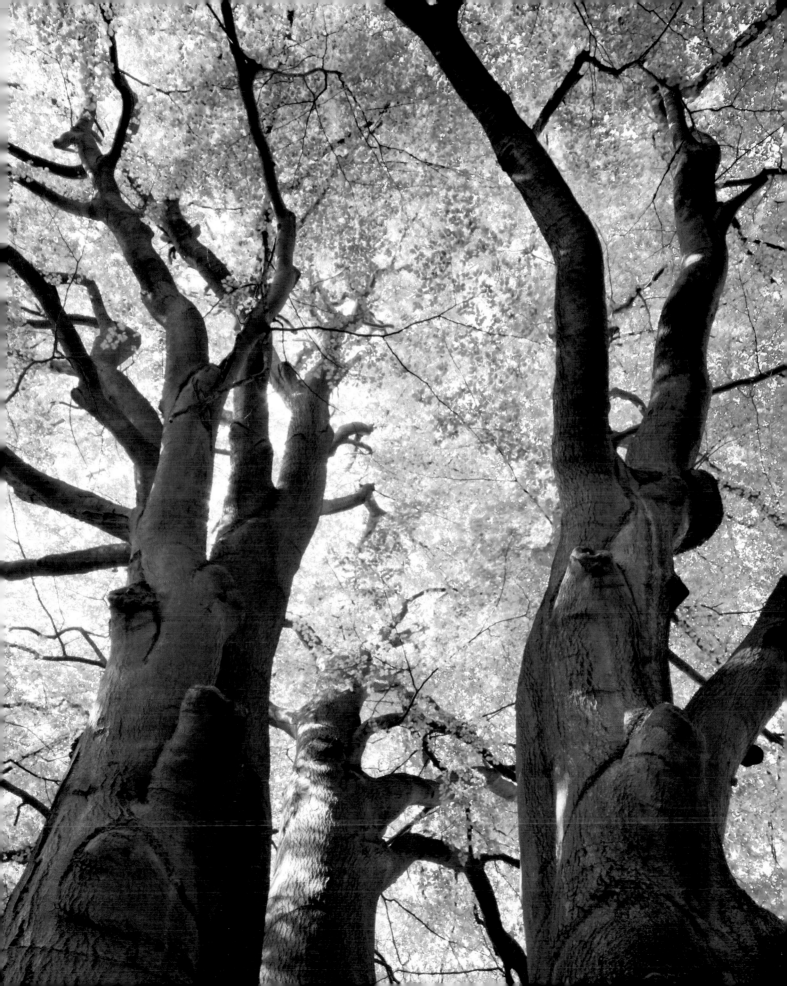

LANDSCAPES

Offering the ultimate in variety of shape, form, colour and mood, it's no wonder that landscape is the most popular photographic genre. Landscape photography, in its strict interpretation, involves capturing scenery – in detail or in general. Landscape shots should not feature people or animals unless they are an intrinsic element of the scene.

There are three key styles in landscape shots:

Representational: direct shots that aim not to interpret a scene but involve finding the best light and shooting position.

Impressionist: in the spirit of the artists who used the same vision, impressionist shots will use more advanced camera technique (or post-shooting manipulation) to enhance more elusive elements of a scene.

Abstract: usually concentrating on details within a wider scene, abstract images may concentrate on shape and form or use extreme exposure to enhance colour or contrast.

AIM FOR
- Strong compositions.
- Foreground interest to balance distant hills and mountains.

WATCH OUT FOR
- High contrast between sky and landscape
- People, vehicles or vapour trails that compromise shots.
- Changing light can provide an entirely different mood in minutes.
- Details – landscape photography is more than just sweeping vistas.

BEST EXPOSURE MODES

- **Aperture priority** – use aperture priority to ensure that you get the correct (usually the maximum) depth of field.
- **Landscape mode** – set this (if your camera permits) and it will automatically be configured for best depth of field.

ESSENTIAL KIT

- **Tripod:** key to getting sharp shots no matter how long the exposure.
- **Graduated filters:** hold back a bright sky to give a more even exposure in-camera.
- **Neutral density filters:** reduce the light getting through to your camera to help you set long exposures.
- **Range of lenses:** landscape photography is not all about sweeping vistas. Details, brought out by using telephoto lenses, can also produce great shots.

METERING TRICK

If you do not have a grey card to hand, zoom in to an area of foliage in your scene and make a note of the exposure. Green foliage has around 18 per cent reflectivity, even though the range of green hues may be very wide. Apply this reading to your recomposed shot and you've a great starting point for the perfect exposure.

18 PER CENT GREEN
Meter off an area of green foliage and you've a great impromptu 18 per cent grey reading.

LAKESIDE CHURCH
A critical assessment of exposure was essential here to prevent the sunlit church from burning out. This meant that some of the shadow areas became very dark but this does not affect either the composition or the overall tonal qualities of the image.

TIPS

- Watch the weather. More so than any other photographic type, the look of a landscape is influenced by the weather. A change in the weather itself or a juxtaposition of clouds can deliver an entirely different interpretation.
- Altering the exposure time can produce a different look. Think of moving water rendered crisp and frozen by a short exposure, or soft and silk-like by a longer one. Very long exposures can produce interesting sky effects and emphasize wind movements.
- Take your time. Though some lighting is transient, on the whole you'll get better shots through being considered about your position, angle and, especially, the Exposure Value.

PORTRAITS

After landscapes, portraiture is the most popular photographic genre. It's hardly surprising as the term covers such a wide range of photography, from social and events, through day-to-day candids and on to the more formal.

YOUNG LADY

The natural lighting on this portrait comes from the sun over the subject's left shoulder. A large white reflector behind the camera reflects that light back into the face of the subject and counteracts any shadowing. The backlighting from the sun also provides for some highlighting of the hair, which helps separate the subject from the background.

Successful portraits depend heavily on getting the exposure spot-on because, as well as the obvious, skin colour can be affected by inaccuracy. Get it right, with a good subject and some inventive composition, and the results can be compelling.

AIM FOR

- A pin-sharp image – soft-focus effects and touching up of blemishes can be attended to later.
- Bright, high-key portraits to convey positive, upbeat characters. Low-key exposures are better suited to character portraiture and more sober moods.

WATCH OUT FOR

- Blurred eyes. Always, always focus on the eyes (this is one rule that should never be broken). If the subject is at an oblique angle, focus on the eye nearest the camera, even if this risks the further eye blurring slightly.

BEST EXPOSURE MODES

- **Aperture priority** – you need to control the aperture to ensure that you get sufficient sharpness across the subject and also control the amount of blurring for the background, if this would otherwise be distracting.
- **Portrait mode** – the Portrait subject mode is a good alternative for grab shots or if your camera does not feature an aperture priority mode.

ESSENTIAL KIT

- **Tripod:** or suitable equivalent support.
- **Good lighting:** provided by the environment or using suitable studio lighting.
- **Reflectors:** essential for filling in shadow areas when shooting with daylight or a simple studio lighting system.

CANDID PORTRAITS

People today are a lot more comfortable with cameras around them. That means your chances of shooting successful candids are much higher. Candids should capture a person in their setting, so the rules of composition should apply; it should also be clear how that person is involved in that setting.

MARKET TRADER
A colourful stall and rule-of-thirds composition help produce a strong scene here. Not an overt portrait, but a good study of the subject in context.

INFORMAL PORTRAIT
An informal portrait can be as compelling as a formal one.

WIDE ANGLE
Shooting with a wide-angle lens creates distorted and slightly humorous results.

URBAN AND CITYSCAPES

Urban photography is often dismissed as merely a subdivision of landscape photography. To a point this is true: a landscape is a landscape, no matter how significant the human intervention in shaping it. But cityscapes provide some unique challenges and opportunities.

GREEK VILLAGE
Mediterranean villages, and those in Greece particularly, are characterized by whitewashed walls and highlights in other bold colours. For this scene the photographer was fortunate in that the shadow areas were indirectly lit by buildings off to the right. The photographer could then accommodate the tonal range from the bright white of the central building and the shadowed areas themselves.

You could actually go further and subdivide urban photography into cityscapes (a more serious interpretation of tourist photography), architectural (where the emphasis is more on architectural style and form) and candid photography. The latter might be regarded as an offshoot of portraiture and is more concerned with street life and characters.

AIM FOR
- Shooting the gritty and the abstract.
- The effect of light (and changing light) on sharp architectural forms.
- Street characters.

WATCH OUT FOR
- High contrast. More so than in a conventional landscape, cityscapes often feature a juxtaposition of bright areas (such as concrete buildings) and dark areas (windows, for example) and it is easy to blow highlights or lose shadow detail.

- Shadows. Bright sunlight can cast streets into deep shadow at certain times of the day.
- Perspective. Unless you choose to deliberately exaggerate perspective, converging verticals (such as the sides of buildings) can be ruinous. Fortunately, the Crop tool in image-manipulation software can provide a quick cure if needed.

BEST EXPOSURE MODES
- **Aperture priority** – as for landscapes you are not concerned with fast movement so can use aperture priority to control the amount of scene in focus.
- **Manual** – for very low light and after dark you would be best advised to go fully manual and monitor the results on the camera's LCD monitor.
- **Night Scene** – if your camera doesn't have manual exposure control, the Night Scene mode can usually be relied upon for good – if not perfect – exposure management.

ESSENTIAL KIT

- **A wide focal range lens:** a wide-angle lens is pretty much essential, but if you've got a super (or ultra) wide, so much the better. Telephoto lenses are useful in capturing details and for shooting inconspicuous candids.
- **Monopod:** tripods can be difficult to deploy properly, especially in busy areas.
- **Mini tripod/support:** for when even monopod use is problematic.
- **Polarizing filter:** not only to work the usual magic on blue skies, but to reduce reflections from windows and glass buildings.

PANORAMA OR DETAIL?

The city allows you terrific scope to shoot intricate detailing or sweeping views. Details provide strong graphic imagery, while more open views are evocative of the location. In composition terms, wide panoramic shots should be avoided unless you plan to reproduce them at large scale.

DETAIL
On the face of a building, these upscale graphics, clad in copper and illuminated by the setting sun, make a striking urban image.

TIPS

- Shooting in the early morning can lead to quite different results to other times of the day. The city streets are quiet and the delicate light so prized by landscape photographers can produce curiously tranquil images.
- Take care that you don't need a permit to shoot in some areas (particularly interiors) or that photography is not banned in some sensitive places.
- Research locations. The most obvious viewpoint may not be photographically the best.
- Explore contrasts. Old and new often sit side by side in the urban landscape.
- Keep going all day – and night. City centres especially remain photogenic after dark, as a myriad of different light sources illuminate landmarks and buildings.
- Don't shoot the obvious – and be mindful of the unexpected.

WIDE VIEW
Wide-angle urban shots are great for showing a feature or landmark in context and giving a better flavour of the location.

NIGHT AND LOW-LIGHT

When the light dips, most inexperienced photographers tend to put away their cameras. That's a shame because these are the conditions when you can shoot some of the most powerful and evocative images. When the light levels fall your eyes' sensitivity to colour tends to fall too and so your photographs can often show the dusky world in – literally – its true colours.

Opportunities for low-light photography abound, from landscapes through to cityscapes and interiors.

AIM FOR

- Sharpness. The risk of blurring through motion or poor sharpness from using lenses at their maximum apertures can easily compromise image quality.
- Balance between light sources. Your eyes' capacity to accommodate wide brightness ranges can easily fool your camera.

WATCH OUT FOR

- Auto flash. Make sure you disable an on-camera flash unit to prevent it determining that the low light levels need a little assistance.
- Excessive electronic noise. High ISO settings will allow for briefer exposures or smaller apertures but, especially in low light, will produce a high level of electronic noise.

BEST EXPOSURE MODES

- **Manual** – for ultimate exposure control.
- **Night Portrait** – adds a burst of flash at the end of a time exposure to correctly expose foreground subjects.

ESSENTIAL KIT

- **Tripod:** to eliminate shake on long exposures.
- **Wide-angle lenses:** if the subjects permit, you will obtain sharper results by using wide-angle lenses.
- **Wide aperture lenses:** let in more light (at the cost of depth of field) but cost more – often considerably more. Vibration reduction/image stabilization further reduces shake and allows for handholding at faster speeds.

UNDEREXPOSE TO ENHANCE COLOUR

The transient colour in the sky around dusk can often be enhanced by modest underexposure. If you bracket your exposures you'll quickly come to recognize how underexposure relates to improved colour saturation.

BURJ AL ARAB
As the sun sets, floodlighting picks out the shapely form. At this stage in the evening, the light from the sky and that of the building is equal so an even exposure results. This was based on the meter's exposure –1 EV to give more saturated colours.

TIPS

- Bracket exposures – even more than you might normally and even if your camera's LCD monitor shows results that appear to be OK.
- If there are people or vehicles moving around your camera's field of view, either increase the exposure time to make them (virtually) disappear or choose an intermediate exposure that will make them appear as fleeting, ghostly shapes.
- Use the self-timer. On some cameras and tripods even pressing the shutter release can introduce modest vibration. You can overcome this with a remote release or, failing that, using the self-timer to trigger the shutter.
- Strike a balance between noise at high ISO and camera shake at low ISO. Many low-light photographers prefer the sharpness of a high ISO setting (with its consequent noise) to the softer images that result from low ISO settings and the risk of camera shake.

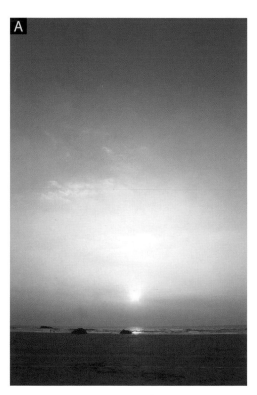 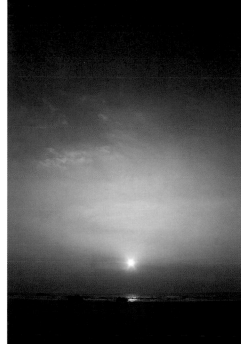

EXPOSE FOR ATMOSPHERE
Accurate but not particularly powerful, the standard metered shot (A) does nothing to enhance the colour – or the mood – of this scene. Reducing the exposure by 1 EV enhances the colour and adds more atmosphere (B). Remember, in situations like this there is no 'right' or 'wrong' in terms of exposure.

CLOSE-UP AND MACRO

Exploring the world of the small and the very small can be a great way of extending your photography and photographic skills. The world takes on – literally – a different perspective. Exposure control under such extreme conditions is remarkably straightforward, although you will need to take care getting the lighting right.

AIM FOR
- Critically sharp images.
- Even illumination.

WATCH OUT FOR
- Shadows due to camera lens.
- Very shallow depth of field.

BEST EXPOSURE MODES
- **Aperture priority** – so you can set the smallest viable aperture to allow the most expansive depth of field.

- **Macro mode** – where this is offered it will set the best (smallest) aperture for the light available and configure the lens to work best at the macro and close-up range.

ESSENTIAL KIT
- **Camera support:** for pin-sharp images.
- **Subject support:** to hold small free-standing subjects conveniently in front of the lens. Together with the camera support, crucial to maintaining subject-to-lens distance.
- **Lighting system:** can be a simple table

lamp or a ring flash. For even lighting a light tent that surrounds the subject and diffuses light is a cheaper and sometimes more effective solution.

- **Close-up kit:** macro lenses, extension tubes or close-up lenses.

SHOOTING FLAT AND LOW-PROFILE SUBJECTS

Flat subjects such as coins, buttons and similar curios are difficult to light evenly. A single light tends to give bright highlights and dark shadows, which can be almost impossible to expose correctly. By using a second light, on the opposite side to the first but with lower brightness (30–50 per cent), you can brighten the shadows, achieve more even illumination and enhance the relief.

Add a black background, and a dark cloth over the camera (to prevent reflection) and you can further enhance the look of reflective subjects. In these cases, the extreme lighting that results demands that you use a grey card for evaluating exposure.

COIN CLOSE-UP
Using crosslighting with a dark background and backing to the camera produces high-contrast results with every detail – including scratches – revealed.

HOUSE FLY
Macro and close-up lenses can let you get in very close, as this shot shows. Seduced by something tasty, the fly was shot using available light. This did mean that the depth of field was very shallow (note the area of the surface that is sharp), but the photographer was able to use the camera's metering system for the shot.

TIPS
- Ensure lighting is even across the frame. With a small-scale subject, the proximity of the light source to one edge of the frame, or one side of the subject, can result in uneven illumination. Consider crosslighting (lighting from both sides) or a light tent, which provides even illumination.
- Watch for distortions. If you are shooting obvious rectangular subjects (stamps, illustrations, for example) you can find that the lens – at the extremes of close-up and macro settings – distorts the image, particularly at the edges of the frame.

EXTREME

What is meant by extreme photography? It's a bit of a catch-all term for those situations where you need to push your photographic skills to the limit. It may be connected with an extreme activity you are involved in: diving or parachuting, for example. Or it may be the conditions you are photographing under are themselves more arduous than the norm: very low-light situations or extreme cold (or heat). Difficult though the conditions may be, they offer the opportunity to produce some truly spectacular images.

AIM FOR

- Sharp images. No matter how extreme the situation you may be in, that can't excuse any lack of technical prowess.
- Appropriate exposure. Here I am not saying 'accurate exposure' because under many extreme conditions the exposure meter reading has little correlation with that required to produce good shots.

WATCH OUT FOR

- Yourself. If you're in an extreme situation (even if it's a lonely city at night), take care of yourself and ensure that you don't put yourself at risk in any way. Great photographers push themselves to the limit to get fantastic shots, but it's important to know what and where that limit is.

BEST EXPOSURE MODES

- **Manual** – in most forms of extreme photography you'll need to take a meter reading and modify this heavily. This can mean that adjustments are beyond the scope of the compensations offered by the camera.
- **Programmed auto** – as if to contradict the previous comment, some situations will work best if you set the camera to auto or program mode and shoot away. Check the results on the LCD monitor and modify them (by applying exposure compensation) if necessary.

SURFER
Luck plays a big part in action photography and more so when it comes to extreme situations. This shot was taken with a wide-angle lens and with the camera's fill-in flash active.

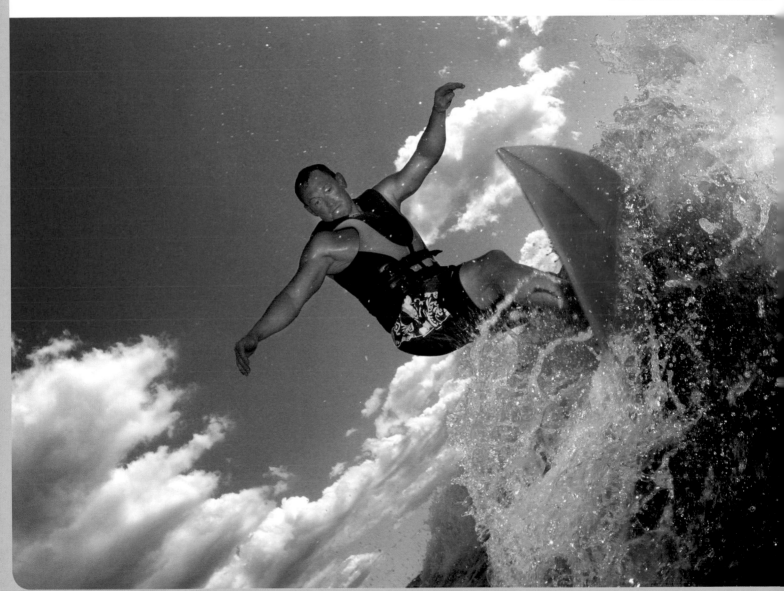

ESSENTIAL KIT

Equipment will depend upon the type of event, location or situation you are shooting but as a rule:

- **Tripod, or suitable equivalent support:** if your exposures are going to be long.
- **Lenses appropriate to the situation:** that could mean ultra wide-angles, telephoto or wide aperture lenses.
- **Specialist equipment:** for example, a waterproof housing if shooting near or under water.

VERY SLOW SHUTTER SPEEDS

Long shutter speeds transform moving objects. For this shot of a fairground ride (above right), the photographer selected a very long shutter speed (8 seconds) to blur the motion of the ride and the riders but the form is still very clear. An extreme blur here is more effective at conveying speed than a more modest blur. Just don't forget your tripod.

EXTREME ANGLES

The combination of a very wide-angle lens, low angle and an action situation produces a very powerful image. A shot like this (right), however, can be staged and involves no risk to the rider or the photographer (the cyclist is doing no more than a static wheelie here). To provide critical sharpness given that the ambient lighting is difficult (the sun is behind the subject's chest), fill-in flash was selected, although using a wide-angle lens makes shooting sharp images much simpler.

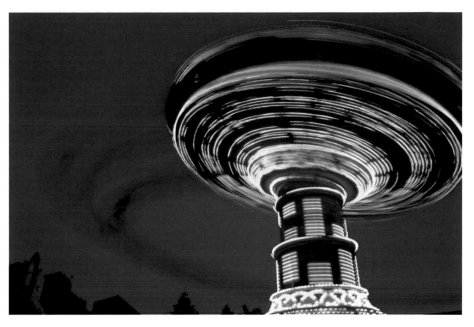

FAIRGROUND RIDE
An extreme exposure of 8 seconds allowed the photographer to select a small aperture (f/11) that ensured sharpness throughout the image.

MOUNTAIN BIKER
A powerful action shot of an extreme sport. Careful framing and lighting helps raise this image from interesting to compelling. The darkening of the edges of the frame (vignetting), which concentrates the viewer's attention on the centre of the image, is achieved by using a lens hood slightly smaller than that recommended for the lens.

> ### TIPS
> - Consider shooting in RAW mode so that you can get the best quality and control over the final images.
> - Shoot lots. When you are working at the limits of your experience and skill, and demanding the most of your equipment, you need to make sure that you have allowed for some contingency. If you've been won over by the benefits of bracketing, now is the time to bracket over an even wider range.

CONTRE-JOUR AND SILHOUETTE

Often, when you shoot towards the sun the aim is to shoot silhouettes. That silhouette might be a mountain range, treescape or even people. Rather than shoot these notional subjects so that they are correctly exposed the aim now is to render these as featureless outlines in total shadow. In these situations the idea of a correct exposure is something of an anathema because there is often a wide range of exposures that give correct results: it is the creative interpretation you impart that will ultimately determine the best setting.

Contre-jour – against the light – shots don't necessarily feature silhouettes, but because they inevitably feature a wide subject brightness range, dark tones will tend to dominate.

AIM FOR

- The best colour in the non-silhouetted areas, and deep tones – or black – for the silhouette. In your contre-jour shots it's usually best to compromise the lighter tones (letting them burn out) and retain the best possible gradation in the darker tones.
- Strong, graphic images. Contre-jour is not about photorealism but about the shape and form in your subject or the landscape. For example, in the image shown opposite, it is the outline of the hot-air balloons that are important, not the detailing that we would otherwise concentrate on when shooting such subjects. Closing your eyes slightly can help you conceive and compose your images, helping you concentrate on form over details.

WATCH OUT FOR

- Backlighting and contre-jour meter modes. These are designed to increase the exposure so that subjects that would normally be silhouetted are correctly exposed at the expense of a background that will consequently burn out.
- Overexposure. Intelligent metering systems in modern cameras can conspire to thwart your attempts at emphasizing the colour of the scene and your attempts to ensure that

foreground subjects are silhouetted. If you are using an auto exposure mode, bracket your exposures and pay close attention to the post-view image. Though you can enhance the effects in your digital darkroom it is, as always, best to get the image right in the first place.

BEST EXPOSURE MODES

- **Aperture priority** – most of your contre-jour and silhouette shots will be landscape-type shots and the same preferences as described there (see pages 118–119) also apply here.
- **Manual** – Often best in extreme conditions, using spot metering (where available) to take selective readings.

TIPS

- Backlighting is perfect for highlighting transparent or translucent subjects, which come into their own when the sun (or appropriate surrogate source) shines through them – think leaves, seed heads and even flowers.
- Though sunlight (in its multiple forms) is the usual backdrop to silhouetted shots, fireworks, bonfires, neon signs and even the moon can provide a novel twist.
- Watch out for the prized halo of light around subjects caused by bright light sources, such as the sun. Light diffracting around a subject (most obviously hair on a person) makes for powerful detailing.

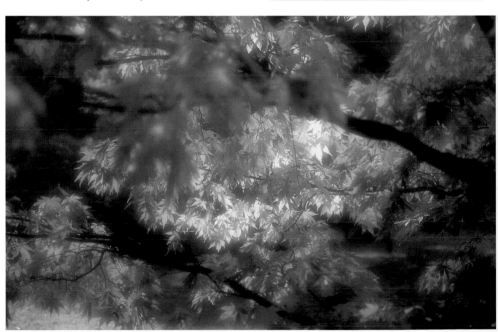

AUTUMN COLOUR
The sun percolating through this group of Acers provides backlighting that enhances the colouration. A spot meter reading was taken from the central areas of the image. Nominally that would lead to underexposure of around 1 stop, but that was ideal for capturing the richness of the colours.

ESSENTIAL KIT

- **Tripod:** for crisp, shake-free images.
- **Lens hood:** the best you can afford.
- **Graduated filters:** for evening out strong brightness ranges.

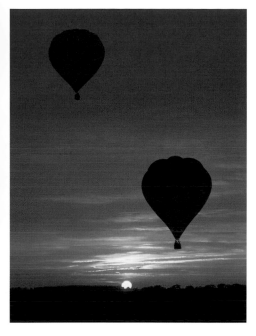

SUNSET BALLOONING
The centre-weighted meter reading for the sky here was reduced by 1.5 stops to enhance and saturate the colour of the sunset. This also produced perfect silhouettes of the balloons.

CHURCH TOWER
The photographer here has emphasized the height of his subject through the diagonal composition. This has the added benefit of giving a more interesting look to the sky itself. By careful positioning – and perhaps a little luck – the photographer has also succeeded in capturing a burst of sunlight through the narrow window. Metering was conducted from the sky itself: the dark area of the church and the bright sunlight would have compromised the levels.

MORNING MIST
This backlit scene of a tranquil jetty, disturbed only by a few gulls, has been exposed for the mist, to retain as much detail there as possible. This has resulted in the highlights on the gulls becoming too bright. The alternative, to ensure the highlights were recorded accurately, would produce only continuous shadows rather than mist detail.

INTERIORS

Getting good exposure for interior shots can be problematic. Lighting in most interiors is not optimized for photography but for utility, in the case of office and public buildings, or mood and atmosphere in residential environments. Professional architectural photographers on assignment will be equipped with a truckload of lighting equipment and lighting power to rival – or exceed – that of bright daylight.

The situation is often further complicated by the mix of lighting sources. If the room lighting itself does not comprise more than one lighting type (each with its own colour temperature), any auxiliary lighting almost certainly will do.

AIM FOR
- Consistent even exposure, using flash or auxiliary lighting in addition to any ambient room lighting.

WATCH OUT FOR
- Difficult colour casts caused by mixed light sources with different colour temperatures.

- Tilted camera. Make sure your camera is perfectly level when shooting any interior, unless you want, for creative purposes, converging verticals and distortion.

BEST EXPOSURE MODES
- **Manual** – interior lighting rarely changes and you'll have full control over any auxiliary lighting.
- **Aperture priority** – you'll need to set a small aperture and this mode will give you the necessary control; you'll also have the necessary control over any flash system you may be using, in TTL mode.

TIPS
- It will be rare that a single shot will give you a good interior rendition and successfully record any exterior views. Consider composite shots or increase the interior lighting level (through ambient lighting or flash) to get a better balance.
- Shooting at dusk can sometimes help achieve a better balance between interior and exterior lighting.
- Turn on, or leave on, the room lighting. It gives a warmer feel to the interiors and more of a 'lived in' look.
- Take care that photography is not banned in some interiors or that you do not need a permit to shoot them.
- Use a low ISO setting for minimal noise.

CHURCH INTERIOR
This stunning church interior was shot using available light. Flashlighting would have been unsuitable (especially considering the wide angle of view) and prohibited. Instead, a long exposure revealed the details, coupled with a small aperture. The long exposure is betrayed by the blurred ethereal figures to the left of the shot.

ESSENTIAL KIT

- **Wide-angle lenses:** most interiors are cramped, some overtly so. You'll need some wide- and ultra-wide-angle lenses to accommodate them.
- **Tripod:** essential for the small apertures you'll need to use to get everything in the interior pin-sharp.
- **Panoramic software:** when even wide-angle lenses are insufficiently wide you may need to stitch two or more images together. Photomerge in Photoshop is a good starting point.

TAKE A CUE FROM ESTATE AGENTS AND REALTORS

These are masters of interior photography. It's in their interests to ensure that the most humble of interiors looks spacious, yet they rarely have the resources to take a properly staged shot. Take a look through their portfolios and pay particular attention to their styles; for grand shots they tend to shoot square-on to facing walls; for emphasizing space they shoot from one corner looking towards the opposite corner.

THE GREAT COURT
This interior of the central courtyard at The British Museum in London is largely lit by daylight, diffused through a glass roof. The white balance needs to be set to match the type of daylight, but care needs to be taken that neutrals are correctly balanced. Care also needs to be taken as dusk falls and artificial lighting contributes to the overall lighting scene. For this scene, which is essentially high-key, the exposure needs to be carefully set to keep the interior a bright white.

LAVISH INTERIOR
For this lavish interior scene, the lighting was balanced for the exterior (visible through the windows). This resulted in the interior becoming warmer than would normally be the case, but in a manner that suits the ambers, oranges and reds of the scene. The photographer took particular care to balance the level of the interior lighting so that the light level of the interior and exterior were balanced.

ACTION

Action photography demands that you concentrate on recording crucial movement: that elusive moment that characterizes the sport, the activity, or the person at the centre of the action. Success demands concentration and, those lucky shots apart, that you've gained some experience. Photographers that are successful in action photography have to put unwavering faith in their equipment and trust it to deliver the critical focus and exposure that they demand. Of course, the same basic rules apply as in any other type of photography.

AIM FOR

- Sharp images.
- Isolated subjects.
- Expressions on faces of subjects.
- The 'decisive moment'. The critical action that occurs in a split second. A fraction of a second before or after will deliver a far less effective shot. It comes with practice.

WATCH OUT FOR

- Spotlighting. Bright subjects with dark surroundings can fool exposure meters, so compensate or spot meter from the subject.
- Distracting backgrounds (and foregrounds).
- Fast-moving competitors. When shooting fast-moving sports and events it can be easy to get carried away and stray into dangerous territory.

TIPS

- Shoot lots. Remember that there's virtually no cost to shooting digitally so you can afford to shoot as much as circumstances and the action permits. This increases the likelihood of that superb jaw-dropping shot.
- Use blur creatively. Sometimes blur adds to an image rather than simply making it unsharp. Of course, the blur I am referring to is that deliberately introduced – or permitted by suitable exposure time – to enhance or exaggerate the action.
- Know your event. If shooting a sports event, even a rudimentary knowledge of that sport will allow you to judge the best places to shoot from.

THEME PARK RIDE
Applying the Motion Blur filter to the ride, apart from the subject itself, gives a terrific sense of speed but without compromising the subjects.

BEST EXPOSURE MODES

- **Shutter priority** – shutter speed is king in action photography; short to freeze fast action, longer to produce motion blurs.
- **Manual** – where the action is taking place in an enclosed space and lighting and subject distance are pretty constant, manual exposure can sometimes be used to deliver the swiftest results.
- **Action or Sports mode** – automatically configures the camera with a bias towards shorter exposure times.

SUPERBIKE
Successful action shots demand good composition, good exposure and spot-on focusing, just like any other shot. Achieving all three with a fast-moving subject can be difficult, but panning with lateral movement here limits the error in focusing. Standard matrix metering was used and a fast shutter speed selected.

ESSENTIAL KIT

- **Telephoto or long zoom lenses:** with the widest affordable maximum aperture.

A CUNNING DECEIT
Freezing action is all well and good, but it can sometimes suggest a lack of motion. In the digital darkroom, you can try using a Motion Blur filter selectively on an image (as in the image shown above) in order to obtain the best of both worlds – a sharp subject and blurred surroundings.

MONOCHROME

Not so much a separate genre, but a distinct slant that can be applied to any other photographic type, monochrome can produce strong reactions, as shape and texture supersede the conventional distinctions (and distractions) due to colour. Remember that monochrome does not mean black and white. Though black and white is a form of monochrome, many monochrome images gain additional impact through the use of a strong colour – and shades of it – that replace black and greys.

AIM FOR
- High contrast, for powerful, dramatic images.
- Emotional scenes. Weddings and other events are great to shoot in colour, but a selection of monochrome shots can be better at conveying emotion.
- Accentuating textures.

WATCH OUT FOR
- Low-contrast images, due to shooting scenes with different colours of similar brightness – bland greys will result.
- Clichéd toned images such as sepia.

BEST EXPOSURE MODES
- Those that you would use for the photographic type (landscape or portraiture, for example). In traditional photography, the mantra for monochrome work was to be 'generous with the exposure and to curtail the development'. Digitally, it is more important to set the exposure to ensure the best capture of highlight and shadow detail.

ESSENTIAL KIT
- Again, the kit you use when shooting in monochrome will be dictated by the photographic genre, rather than your intention of shooting in monochrome.

JUST MARRIED
Perfect exposure here was demonstrated by metering off the bride's face (with the focus being set on her right eye). Centre-weighted and even matrix metering could have been compromised by the light veil or dark background. A short shutter speed helped critical focus at the expense of depth of field.

- Some digital exponents of monochrome photography do use coloured filters (the same as they might use if shooting with black-and-white film) to enhance tone at the shooting stage, but as similar effects can be achieved later when manipulating your images in the digital darkroom, these are not essential.

DIGITAL MONOCHROME FILTRATION

Photographers who shoot in black and white use colour filters to enhance and suppress elements of the scene (such as red, to render vivid blue skies dark). You can do the same in Photoshop by splitting the image into Channels, corresponding to filter colours. Or you can apply a digital filter to the image prior to removing the colour.

TIPS

- Don't shoot in black-and-white mode (even if your camera permits). Instead shoot conventionally and remove the colour in your image-manipulation software. However, previewing your image on the camera's LCD monitor in black and white can be useful.
- Photoshop users can use the black and white adjustment layer (introduced in CS3) to control the Channel mix and exposure.
- If you're serious about black-and-white photography, consider specialized ink sets for your inkjet printer: these replace colour inks and allow a better and more authentic print.

WATERFALL
Shots of waterfalls can work very well in monochrome. The strength of an image like this is in the power of the waterfall and the form of the water. There is also the wide subject brightness range to consider in a scene such as this. The photographer here took an exposure reading from the water and underexposed by 1 1/3 stops.

SPLITTING CHANNELS
Splitting a colour shot into its monochrome Channels can produce multiple images with quite distinct looks such as this. Primary colours appear black or white according to which Channel they appear in (shown here as red, green and blue Channels respectively).

GLOSSARY OF EXPOSURE TERMS

18 per cent grey An arbitrary measure of medium tone; represents an object that reflects 50 per cent of incident light.

AE *see* Automatic exposure.

AF *see* Autofocus.

Ambient light The light – artificial and natural – in the environment (i.e. not provided by the photographer or camera).

Angle of view The angular view of a scene given by a camera lens.

Aperture The opening in a lens formed by the iris diaphragm inside the lens. The size of the aperture can be made larger or smaller automatically in response to incident light or by manual control.

Aperture priority An exposure mode on a camera that lets the photographer set the aperture manually and have the shutter speed setting adjusted automatically.

Aperture ring A ring on the barrel of a lens that permits the adjustment of the lens aperture. Not found on all cameras or lenses.

Auto-bracketing A control that automatically brackets exposures (*see* Bracketing).

Autofocus (AF) Focusing system that automatically focuses on a subject or point determined by photographer.

Automatic exposure (AE) Camera mode setting that automatically adjusts the aperture, shutter speed, or both to produce an accurate exposure.

Automatic flash An electronic flash unit that incorporates a light-sensitive cell to measure the amount of flashlight and quench the flash when sufficient light has been emitted.

Backlighting, Backlit Light source that illuminates the subject from behind; usually requires exposure compensation (or fill-in flash) for accurate exposure of the subject.

Balanced flash, Balanced fill flash A flash system that integrates the camera's metering system to balance the amount of flashlight with ambient light to brighten any shadow areas.

Bracketing Shooting several shots of the same scene consecutively with different exposure settings.

Burning in Originally a darkroom technique for giving additional exposure to parts of an image being printed to paper to make those areas darker; a similar technique using a Burn tool in image-manipulation software.

Cast, Colour cast Overall colouration of an image due to the influence of a non-neutral coloured light source. Can be corrected in camera using the white balance control, using colour-compensation filters or digitally using software.

CCD *see* Charge-Coupled Device.

CCD raw format The data collected from an image sensor prior to the normal electronic processing.

Centre-weighted metering Metering system that measures the brightness from the entire frame but is biased towards the central area, making it especially suitable for portraiture and general photography.

Charge-Coupled Device (CCD) An image sensor that converts incident light to electrical charges on photosite pixels that can be read and converted to an image.

CMOS *see* CMOS image sensor.

CMOS image sensor An image sensor created using CMOS technology. Works in a similar way to a CCD but tends to consume less energy.

Colour balance A partially subjective interpretation of the colours in an image when compared with a reference image or the original scene.

Colour depth The number of digital data 'bits' assigned to each pixel in a digital image. The greater this number the more precisely a colour can be defined. Usually a colour depth of 24 bits per pixel is used (8 bits each for the red, green and blue components of the image) to give a total possibility of 16 million colours.

Colour temperature The description of the colour of a light source by reference to the theoretical scale of colour produced by an ideal 'perfect radiator'.

Contrast The tonal range between the shadow and highlight areas of an image.

Depth of field The distance between the nearest and furthest areas in a photograph that are judged to be in acceptably sharp focus. Depth of field varies according to lens aperture and camera-to-subject distance.

Dodging The converse of burning in, originally a darkroom technique for reducing the amount of light to selected areas of a print to allow them to be printed lighter than would otherwise be the case. Now a digital image-manipulation technique.

EV *see* Exposure Value.

Exposure compensation The ability to adjust a pre-set exposure by up to 3 stops to lighten or darken the image compared with the meter's suggested value.

Exposure/focus lock A camera control that allows the exposure and/or the focus to be locked when a subject is in the viewfinder to allow recomposition of the scene without affecting the exposure or focus settings.

Exposure meter An in-camera or handheld device designed to accurately measure the light levels incident upon it and (in the case of handheld devices) calibrated for direct incident light or that reflected from a scene.

Exposure Value An absolute measurement of light that can be measured on a meter and that can be configured as a series of aperture/shutter speed combinations.

F-stop, f-number A setting of the lens aperture. Normally consecutive f-stops are factors of two of the aperture opening (f/4 is half the aperture of f/2.8, for example). F-number is often used to describe the maximum aperture of a lens.

Filter A piece of optically transparent material placed over the lens of a camera to modify the incoming light by colouring, diffusing or attenuating the light. Also a term used to describe digital effects that modify images in a similar way (or often, in more extreme ways).

Flash, fill Flash used to fill shadows that would otherwise be rendered too dark in an image. *See also* Balanced fill flash.

Flash, ring A special flash system that is circular and mounts on a camera lens' filter mount and used for close-up photography or special-effect lighting.

Flash, slave A flash that is triggered with light from another (usually camera-mounted) flashgun.

Frontlighting Lighting from sources behind the camera and shining face-on the subject.

Grey card A card that reflects 50 per cent of the incident light, often used for calibrating exposure meters and equivalent to the mid-tones in a scene.

Grey scale A series of 256 tones raging from pure white to pure black that is used as a map of the distribution of tones in an image.

High Dynamic Range (HDR) A scene or image in which the range of brightness levels from the brightest to the darkest is higher than normal and that generally can't be recorded using conventional photography. Can be represented by combining bracketed exposures.

Highlight A bright, or the brightest, part of a scene that can be the first to lose detail if not correctly exposed.
Image sensor *see* Charge-Coupled Device, CMOS image sensor.

Incident light Any light falling on a subject. This light is measured by a light meter in incident light mode.

Inverse square law The physical law that describes the way that the illumination from a light source falls off with distance: as the source-to-subject distance doubles, the light falls off by a factor of four. Can be used to calculate or anticipate fall-off in illumination from a camera flash system.

LCD monitor *see* Preview screen.

Light meter *see* Exposure meter.

Matrix metering A metering system that calculates the exposure from measuring a series of discrete contiguous areas of the scene.

Multi-mode metering A metering system that allows the selection of one of several different exposure modes usually including fully auto, aperture priority, shutter priority and manual.

Multi-segment A metering similar to matrix metering, metering based on a complex pattern of metering areas.

Neutral density A filter that has no colour but attenuates (reduces) the incident light. Useful where wide apertures are required for a shot but high light levels may otherwise preclude such settings.

Noise The result of electronic fluctuations in the imaging system of a digital camera and appearing similar to grain on film. Setting the camera sensitivity higher will result in higher noise levels.

Open up The opposite of stop down, the opening of the lens aperture to a wider setting (although it is now also used to describe any increase in exposure where camera settings can't be explicitly interpreted as an aperture increase).

Overexposure Exposing the image sensor of the camera to more light than is suggested by the meter and is needed to capture the scene. Can be intentional or unintentional and usually results in too light an image.

Photosite A small area on the surface of a CCD or CMOS image sensor that records the brightness for a pixel in the image.

Preview screen LCD display screen on the back of the camera used in addition to or in place of a viewfinder to compose photographs and, after shooting, to review the results.

Program/Programmed exposure A fully auto exposure mode that automatically sets aperture and shutter speed.

Red-eye Effect that causes the centre of people's eyes to look red in flash exposures, due to the flashlight reflecting from the subjects' retinas.

Red-eye reduction mode A flash mode that fires a single or multiple flash bursts to attempt to reduce the size of the iris on subjects prior to the main flash exposure.

SBR *see* Subject brightness range.

Scene modes Specialized shooting modes that pre-configure both the exposure and other camera settings (such as focus, flash) for specific situations such as action, portraiture and night photography.

Shutter The part of the camera that opens and closes to let light from the scene strike the image sensor via the lens and shutter.

Shutter priority mode A semi-automatic exposure system where you set the shutter speed and the corresponding aperture is set automatically by the camera.

Shutter speed The length of time the shutter is open and allows light to reach the sensor.

Sidelighting Light falling on a subject from the side, resulting in bright areas and shadows.

Spot metering A metering system that measures the light from a small circle in the centre of the viewfinder, or a smaller circle when using a handheld spot meter.

Stop (1) A setting of the aperture that determines a specific lens opening.

Stop (2) A change in exposure by a factor of two (or one-half). This may comprise changing the aperture by one f-stop or altering the shutter speed by a factor of two (or one-half).

Stop down A decrease in the size of the lens aperture. The opposite of open up.

Subject brightness range (SBR) The range of brightness levels between the brightest and darkest parts of the image.

Through-the-lens (TTL) metering Metering system usually found in SLR (and some other) cameras where the inbuilt exposure meter uses the same view of the scene as that visible through the viewfinder.

Underexposure Exposing the film to less light than required for an exposure as determined by the exposure meter. This may be intentional or unintentional and generally results in too dark an image.

White balance An automatic or manual control that adjusts the colour balance of an image to neutralize colour casts. Can be configured to compensate for specific lighting types.

PICTURE CREDITS

All images taken by the author except:

Front cover © Michael Prince/Corbis

pp74–75 Three Exposures and Composite HDR Image; pp110–111 Source Images and HDR Image © HDRsoft

p5 River; pp10–11 Varying Shutter Speed (and back cover); p19 Flowing Water; p30 Backlit Butterfly; p57 Coastline at Sunset; p77 The World in Miniature; p126 House Fly; p130 Church Tower © Ross Hoddinott

p2 Tree Canopy; p6 Long Exposures; p7 Bike and Rider; p15 Yellow Bridge; p20 Evening Flight; p21 Extreme Lighting; p27 Chicago Skyscrapers; p33 Buddhist Temple; p35 Antelope Canyon; p40 Underwater Mode; p41 Fireworks Mode and Candlelight Mode; p49 Yacht in the Evening Sun; p59 Heron at Sunset; p86 Nature Photography; p117 A Matter of Balance; pp128–29 Surfer, Fairground Ride and Mountain Biker; p133 Lavish Interior © Istockphoto.com

p9 Starfish; p26 City of Arts and Science at Dusk; p93 Evening Light; p118 Lakeside Church; p122 Greek Village; p132 Church Interior; p133 The Great Court; p137 Waterfall © Tom Mackie

p135 Superbike © MC IA/Milagro

p89 Frog © Nikon UK Limited

p25 Romantic portrait; p136 Just Married © Julie Oswin

p23 Portrait with Sidelighting; p24 Backlit Portrait; p31 Papaver Poppy Seed Heads; p83 Multiple Flash Portrait; p90 Low-key Portrait © Cathy Waite

pp28–29 Lakeland Dawn © Steve Walton

Product shots:
p37, p79 © Canon Limited; p53 © Olympus Limited; p12, p16, p18 © Panasonic Limited; p12, p36, p39 © Nikon UK Limited; p42 © Sekonic; p43 Grey Card, p85 Reflectors and Supplementary Flash © Lastolite; p77 ©Sigma

ACKNOWLEDGMENTS

A big thank you to Neil Baber and Freya Dangerfield, for giving me the chance to write this book. My thanks too to Demelza Hookway and Eleanor Stafford at David and Charles, and to Nicola Hodgson, for helping shape the book into what you have read – and hopefully enjoyed – here.

Special thanks must go to Ame Verso who worked closely with me in shaping the text and getting the imagery just right. I'm pleased to say that she kept giving her support even when a new baby intervened! My best wishes to you and your family, Ame.

A book on exposure naturally demands photography of the highest quality. I was fortunate in undertaking this work in being able use work from photographers that I have long admired. My thanks, therefore, go to Ross Hoddinott and Tom Mackie for the wonderful (and perfectly exposed!) landscapes and close-ups. To Steve Walton and Julie Oswin whose work I was first drawn to in the D&C book *Contemporary Wedding Photography*. And to Cathy Waite for those bold and intriguing shots that exemplify good command of exposure and illustrate a great photographic style.

A final thank you to my family for both putting up with me working away on the computer late into the nights and providing the material for those impromptu photographs. It is through their patience and tolerance I am able to do something – photography – that I so enjoy.

WEBSITES

HARDWARE & ACCESSORIES
Cokin Filters www.cokin.com
Expodisc www.expodisc.com
Hoya www.intro20202.co.uk
Lastolite www.lastolite.com
Tiffen www.tiffen.com
Sekonic Light Meters www.sekonic.com

SOFTWARE & SOFTWARE SUPPORT
Adobe www.adobe.com
Apple www.apple.com
HDRsoft www.hdrsoft.com
National Association of Photoshop
 Professionals www.photoshopuser.com

FEATURED PHOTOGRAPHERS
Ross Hoddinott www.rosshoddinott.co.uk
Tom Mackie www.tommackie.com
Julie Oswin www.julieoswin.com
Steve Walton www.fineartimages.co.uk

ABOUT THE AUTHOR

Peter Cope is an experienced photographer and author. His interests in digital technology began at university where he worked on the development of electronic assemblies – image photon counting systems – that would ultimately lead to the imaging sensors used in today's digital cameras.

Peter has lectured extensively on photographic and digital subjects and his work has appeared in a number of magazines in the UK and the US, including *What Digital Camera*, *Total Digital Photography* and *Digital Pro*.

He lives near Bristol with his wife and two young children.